BRITAIN IN OLD PHOTOGRAPHS

T0353101

WORKING OXFORDSHIRE

FROM AIRMEN TO WHEELWRIGHTS

MARILYN YURDAN

The History Press

First published 2010

The History Press
The Mill, Brimscombe Port
Stroud, Gloucestershire, GL5 2QG
www.thehistorypress.co.uk

© Marilyn Yurdan 2010

The right of Marilyn Yurdan to be identified as the Author
of this work has been asserted in accordance with the
Copyrights, Designs and Patents Act 1988.

All rights reserved. No part of this book may be reprinted
or reproduced or utilised in any form or by any electronic,
mechanical or other means, now known or hereafter invented,
including photocopying and recording, or in any information
storage or retrieval system, without the permission in writing
from the Publishers.

British Library Cataloguing in Publication Data.
A catalogue record for this book is available from the British Library.

ISBN 978 0 7524 5585 3

Typesetting and origination by The History Press
Printed in Great Britain
Manufacturing managed by Jellyfish Print Solutions Ltd

CONTENTS

ACKNOWLEDGEMENTS

Thank you to John Brown, Chris McDowell and Newsquest Oxfordshire Picture Library, which supplied the photographs in this book.

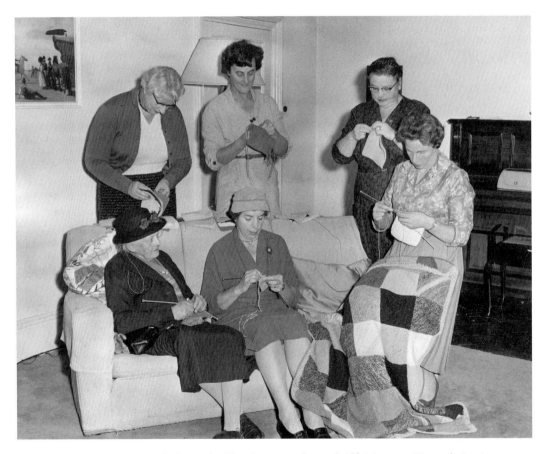

Unpaid work but nonetheless valuable; these members of Old Marston Women's Institute are making six-inch woollen squares to be sewn up into blankets for World Refugee Year in 1959. Pictured busily knitting away in the home of Mrs E.L. Harley are, standing from left to right, Miss E. Drummond, Mrs S. Tompkins and Mrs M.M. Frost. Standing are Mrs I. Baldwin, Mrs Harley, and Mrs F.G. Puddephatt. WI members all over Oxfordshire took part in this project.

INTRODUCTION

Because Oxfordshire's major employers are famous worldwide and have had a great deal written about them, this book concentrates on some of the county's lesser-known occupations, although the University of Oxford, the car industry and blanket-manufacturing have not been excluded.

The work of today's craftsmen tends to be of an artistic rather than a practical nature but until the middle of the last century this was far from being the case. For centuries craftsmen have produced handmade items, beautiful in their own way but designed for practical use rather than decoration. Among the craftsmen who appear in this book are blacksmiths, wood turners, carvers and engravers, wheelwrights, thatchers, clockmakers, stonemasons and even a harpsichord factory. Some have managed to turn what started as a hobby into a business, such as making toys or lace.

The name Oxford is, of course, synonymous with education but many more people are employed in learning in its widest sense than might be imagined. The most obvious are the university's academic community, but literally hundreds of others are employed in administrative, library and clerical posts, in cleaning and maintenance, and in laboratories, kitchens, parks and gardens of the university and its colleges. Apart from the two universities in Oxford, throughout the county there are Colleges of Technology and Further Education and dozens of schools with pupils at all levels. It might even be argued that students fall into the category of worker! Also contributing to Oxfordshire's educational system is the expertise of its printers, publishers, booksellers and, of course, the local press.

The essential services in any community range from those provided by the emergency services to the military, from prison warders to bus conductors, railway porters to nurses, and numerous examples of such workers are included in the book.

Despite the rapid growth which took place throughout the second half of the twentieth century (and which shows no sign of abating), Oxfordshire remains an essentially rural county. With no large industrial towns, most of its social and economic life is centred round market towns like Banbury, Bicester, Thame and Witney, each of which has its own satellite villages.

Farming – dairy, arable and mixed – is very much part of the Oxfordshire countryside and there are some sizeable estates – notably the Marlborough estate centred on Blenheim Palace and the Lockinge estate near Wantage, which includes several villages. For centuries Harwell has been famous for its cherry orchards and Ewelme for its watercress, but less well known were the hop-fields at Southmoor which attracted many temporary workers at harvest time.

Agricultural shows and country fairs are still very much a part of rural life, especially the annual Oxfordshire County and Thame Show, which evolved from separate events.

For over a century Thame Show was billed as England's greatest one-day show, although it has recently been extended to become a two-day event.

Shops and businesses of the past are those businesses which have undergone the most change and they are normally the ones which are best remembered, often with affection. Not surprisingly, the majority of the examples in the book have been taken from Oxford itself, although there are some from other parts of the county. A few shops became institutions, organising social events and outings for their staff, long before the concepts of teamwork and 'bonding' were ever conceived.

Looking back, some of the most surprising aspects of shopping before the general advent of the chain store were the variety of items stocked by individual shops, the personal service offered to customers and, of course, the prices. Many businesses were family affairs and some continued to use the family name long after they had been taken over by larger concerns, until they were eventually swallowed up by high street chains for amalgamation or demolition.

Charters permitting markets to be held in Oxfordshire towns and villages were granted in medieval times, and although a few have been discontinued, the great majority thrive to this day, some places holding more than one market a week. Oxford's Covered Market, opened in 1774, is a visitor attraction in its own right.

Although the outstanding local examples of the manufacturing industry are indisputably 'the Works' (now the BMW car plant) at Cowley, MG cars at Abingdon, and blanket-making at Witney, Oxfordshire has been the home of a range of smaller industries. In the centuries-old business of glove-making, employees worked in their own homes as well as the numerous little factories which were to be found to the west and north of the county, in and around Wychwood Forest. Generally, such businesses grew up where raw materials such as wool and hides were readily available.

The production and purveying of food and drink also has a long history and apart from the legendary Banbury Cakes, Oxfordshire has a tradition of famous names like Oliver and Gurden (more cakes, as well as puddings), Cooper's Marmalade, and Brakspear's, Morland's, Wychwood and Hook Norton breweries. Virtually every town and village in Oxfordshire has at least one fine public house, many of them centuries old.

Light industry, typically mechanical and electrical engineering and repairs, boat-building, furniture-making, printing, food production, haulage and storage, gradually grew up in Oxford and around the larger towns. However, apart from the car industry, Lucy's ironworks in Jericho and Alcan at Banbury, there has been little heavy industry.

It is heartening to find that many of Oxfordshire's long-established workplaces survive in one form or another to this day. Some continue to play a role in the economic life of the county, doing what they have always done best, while others have adapted to the times and some of the casualties have been replaced. Small businesses are still flourishing, sometimes tucked away down alleyways off the main streets of our towns, sometimes relocated to trading estates on the outskirts. The production of Banbury cheese may have stopped long ago, but the town's cakes are still made and exported all over the world.

Marilyn Yurdan, 2010

1

CRAFTS

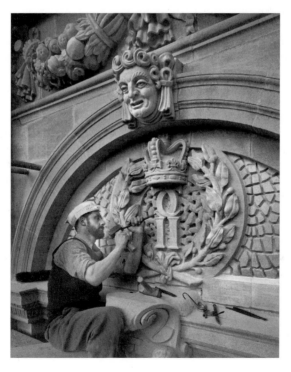

Thomas Hardy's Jude the Obscure, who had trouble keeping his black curly hair and beard free from dust, would have appreciated the headgear which this enterprising stonemason has made for himself. Pictured here in 1959, he is using traditional tools to re-carve the cipher of King Charles II during the restoration of the Sheldonian Theatre.

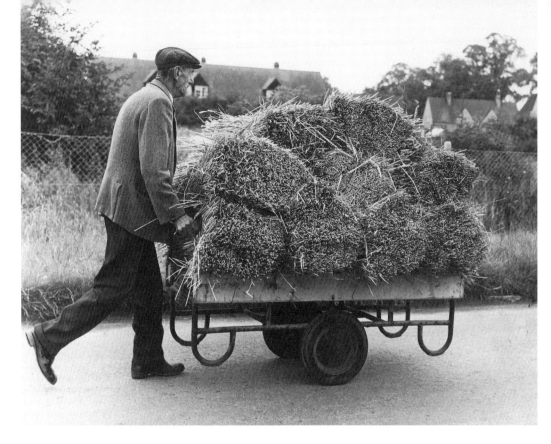

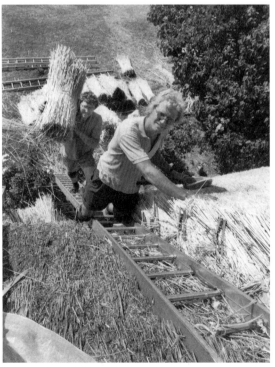

A veteran thatcher at work in August 1991; Fred Davis of Sutton is shown transporting a barrow-load of straw while working on a cottage at nearby Stanton Harcourt. Mr Davis, then aged 76, had been thatching for sixty years. Thatched buildings are still very much a feature of Oxfordshire villages and far from being a dying craft, there are currently more than twenty thatchers in the Oxford area phone directory alone.

Pictured at work carrying on the family tradition in August 1991 are Master Thatcher finalists at Brightwell-cum-Sotwell, Ian (top) and Kit Davis (bottom). In 2008, the present business, Kit Davis & Co., which is based at Steventon, won the prestigious contract for the repairing and re-ridging of the Globe Theatre on London's South Bank.

Among those taking part in the Crafts Festival at Ginge Pottery, near Wantage in November 1998, was David Derrick, who gave a demonstration of how to make a straw beehive. Known as skeps, these older-style hives were superseded by the more sophisticated wooden types.

Arguably the most important craftsman in any village was the blacksmith. Not only did he carry out essential work of his own, in the days before mass production he would also make tools for others to use – and, of course, his smithy was often the only warm place in the village! Roy Matthews is shown working in the smithy at Brize Norton in March 1959.

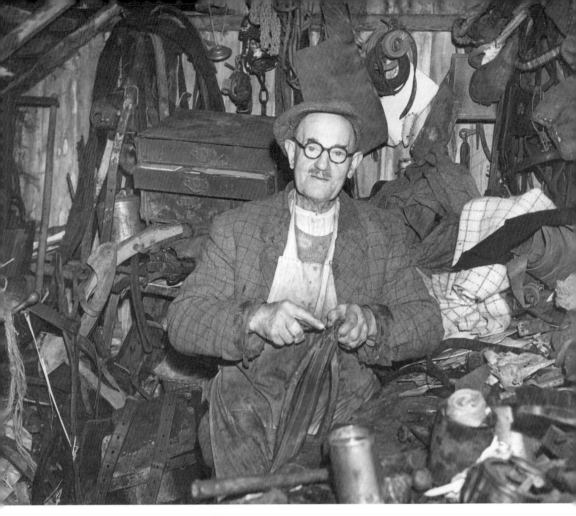

A well-known character in the village of Cropredy was harness-maker Jim Bonham, captured on film in his workroom when he was in his eighty-third year. Harness-making, once an important part of rural life, declined rapidly when horses were replaced by motor vehicles, but Mr Bonham kept at the heart of Cropredy life by acting as Banbury Rural District councillor for about forty years and was chairman of the parish council for many years. He claimed his healthy old age was due to shunning both alcohol and tobacco.

Opposite above: It is possible nowadays for aspiring blacksmiths to take a course at the 200-year-old forge at Banbury. These range from making a poker in two hours to a two-day intensive course. Gift vouchers are also available. Pictured here in 1965 at his forge in Lower High Street, Thame, is Rupert Timms, one of a long line of blacksmiths and farriers. The forge closed for a short time after the Timms family gave it up, but has since reopened.

Opposite below: After the decline in the number of horses which needed shoeing, smiths turned their hands to decorative ironwork and some became cycle or motor mechanics. Strictly speaking, shoeing horses is the business of a farrier rather than a blacksmith, although the jobs overlapped. These ornamental gates were made for the royal enclosure at Ascot in 1955 by the Rathbone family of Kingham. They are, from left to right, father James and sons Reg and Fred.

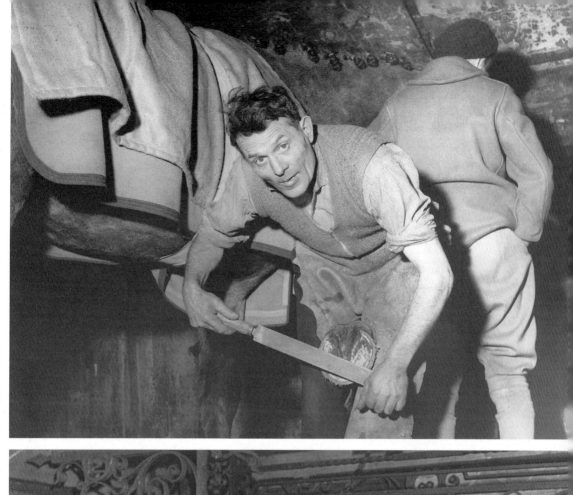

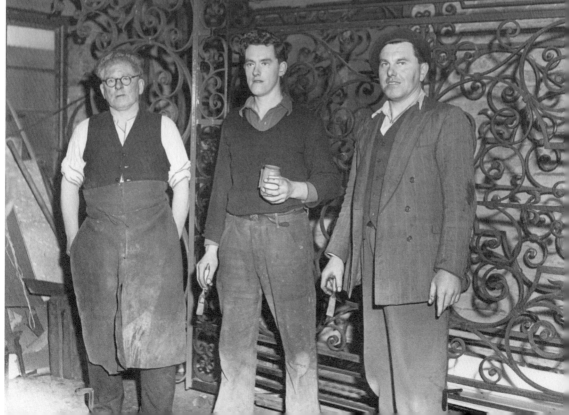

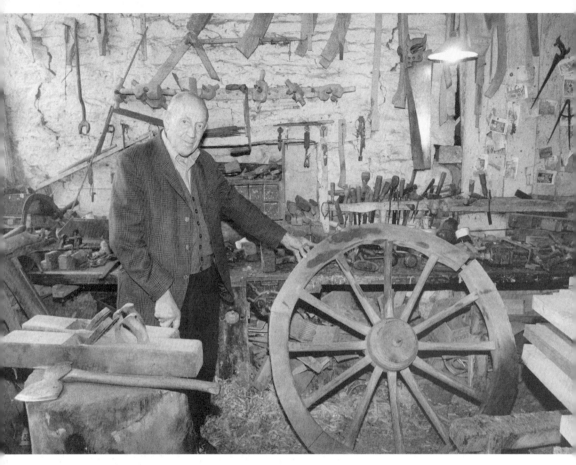

The wheelwright was another important member of village society. One long-lasting business was at Aston Bampton, where the Long family was prominent. In addition to being wheelwrights, they were also publicans, blacksmiths and undertakers, and the family still runs the post office. Seventy-three-year-old Aubrey Long is shown here in the family wheelwright workshop in 1980.

In 1958 the tools used by woodworkers had changed little over the last two centuries, and Arnold McIntosh's workshop in Oxford's Castle Street produced bowls and dishes following designs dating back some 400 years. However, Mr McIntosh also owned an up-to-date lathe which could produce a table leg in fifteen seconds.

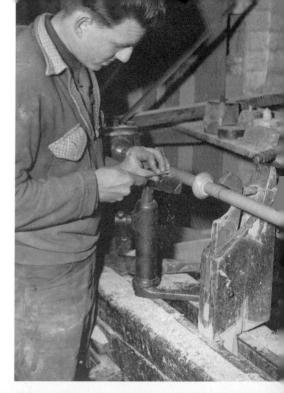

Shortly before Christmas 1958, Peter Baker of Caroline Street, St Clements, Oxford was hard at work carving one of a number of tracery panels, which were only a part of a large and elaborate oak screen for a church, all of it made by hand.

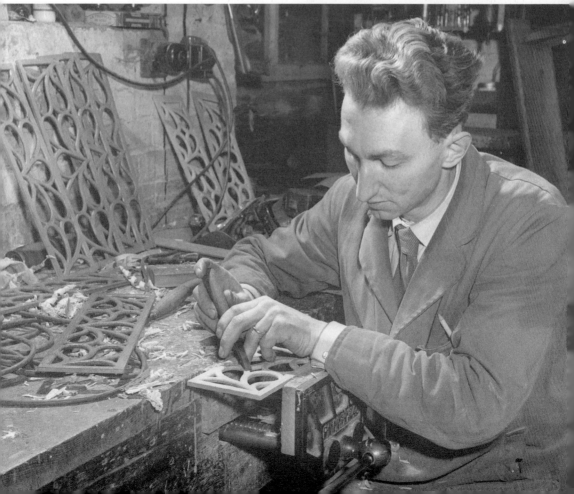

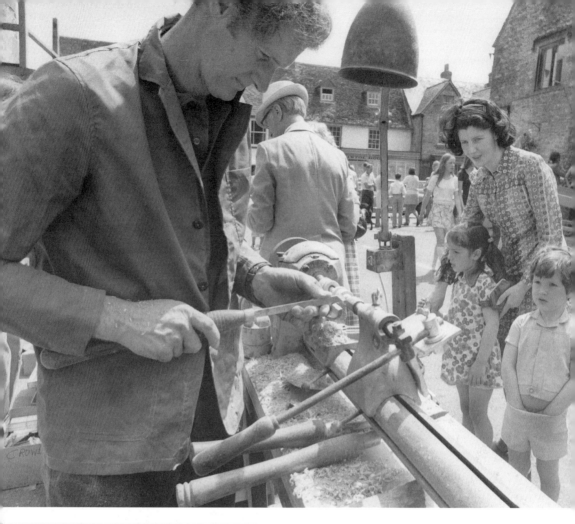

By 1959 there were very few makers of oars left in the world but one of them, run by the Collar family, was still in business in Jubilee Terrace, near Oxford's Folly Bridge. Around twenty-four craftsmen, all of whom had served a five-year apprenticeship, turned out an average of 500 oars each week. Ronald Cousins is shown shaping an oar using a specially designed plane.

The Cotswolds continue to be known for the survival of country crafts and among those demonstrating their work at the craft fair — which was held in Burford in June 1974 — was Tim Green, shown hard at work at his lathe.

Other items needed to equip the county's churches were candlesticks. Although one tends to think of these as being made of silver or some other metal, wooden ones were also in use and these were also carved by hand, as this 1958 photograph of Fred Reeves of Cowley Road shows.

Woodwork was on the curriculum as part of a scheme for training unemployed school-leavers in Oxford in 1982. Trainee Martin McInerney proudly shows off the tortoise truck which he made at the Community Workshop on the site of the former Cowley Road Hospital.

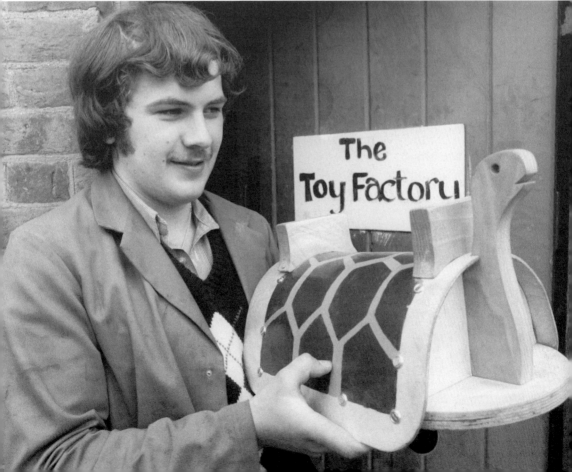

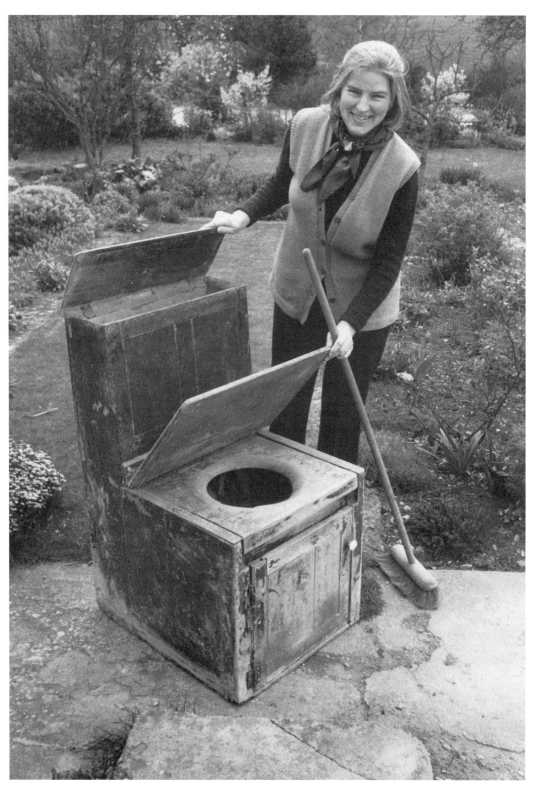

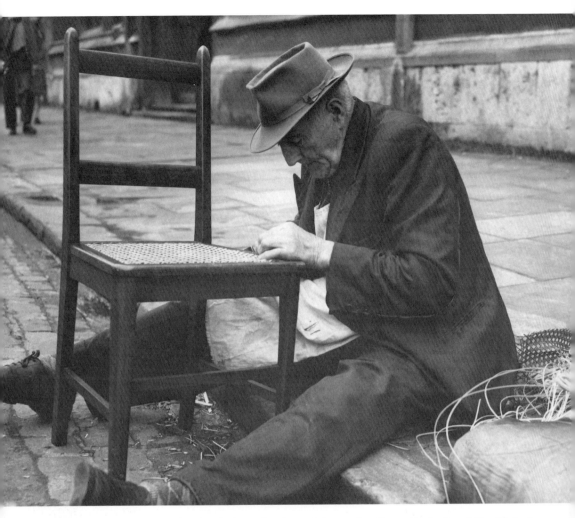

This chair mender is totally absorbed in what he is doing as he sits on the kerb outside All Souls College in the busy Oxford High Street in November 1958. As the newspaper reporter wrote: 'Deft fingers and an eye for the pattern of a cane seat, make this craftsman a welcome visitor to many places where there is work for him to do.'

Opposite: One unusual wooden artefact was this Victorian earth closet which was found in a shed at North Leigh. It bears a small brass plaque reading 'J. Parker's Patent Automaton Earth Closet, Woodstock, Oxford.' Owner Elizabeth Seager poses in 1976 with the closet, which is estimated to date from 1870-86, before it went off to the County Museum to form part of a display. The museum was delighted with its acquisition as it had been on the lookout for an example of Parker's work for some time.

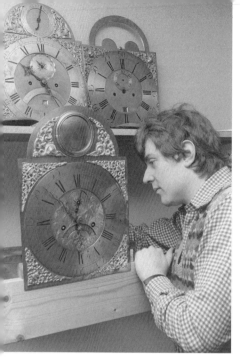

Antique clock restorer Ed Stewart is shown with a trio of eighteenth-century timepieces in the workshop at his home in Newland, Witney in 1979. A former electronics technician, he left his job with Oxford University in order to take a British Antique Dealers' Association course and went on to open his own business.

A very unusual business — constructing seventeenth and eighteenth-century-style musical instruments such as harpsichords, spinets and clavichords — was started in Headington by Robert Goble when he moved there in 1947. Shown in this 1958 photograph are Robert's son Andrea, technician Andrew Douglas and Robert Goble himself. Today the business is run by Andrea, who hires out harpsichords for use at performances all over the Oxford area.

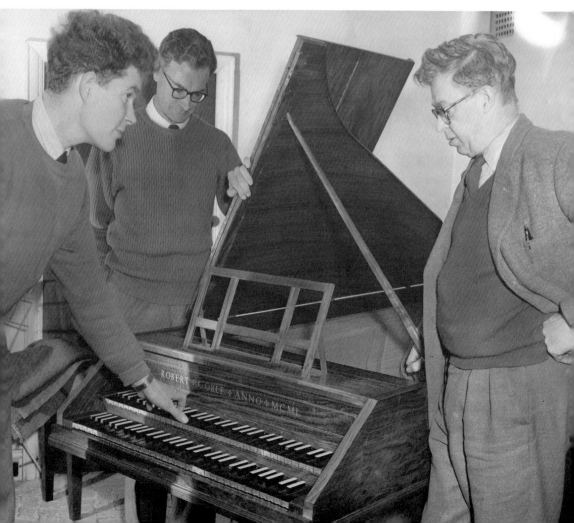

Keeping Oxford's colleges in a good state of repair is an ongoing and skilled occupation. Shown here patiently arranging and pressing down cobblestones in the Front Quadrangle of Merton College in October 1970 is Tom Dore, whose patience and expertise did much to enhance that part of the college. The pattern of Merton's cobbles was afterwards copied when the Front Quad of Green-Templeton College was designed.

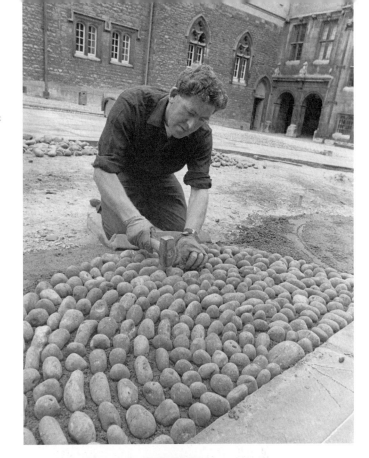

More stonework at Merton College; this is one of eight new two-ton gargoyles being swung into place on the college chapel with the help of an 85ft-crane in 1968. Their medieval predecessors had become so worn that it was decided to replace them. The new carvings were designed as copies of the originals by Percy Quick of Oxford builders Sym & Co., using Clipsham stone from Rutland.

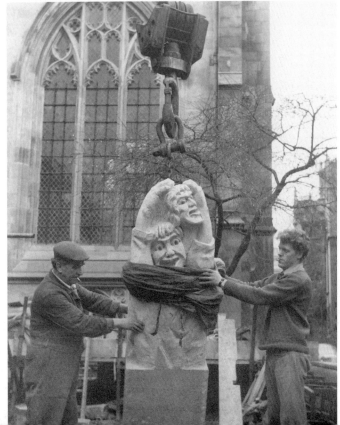

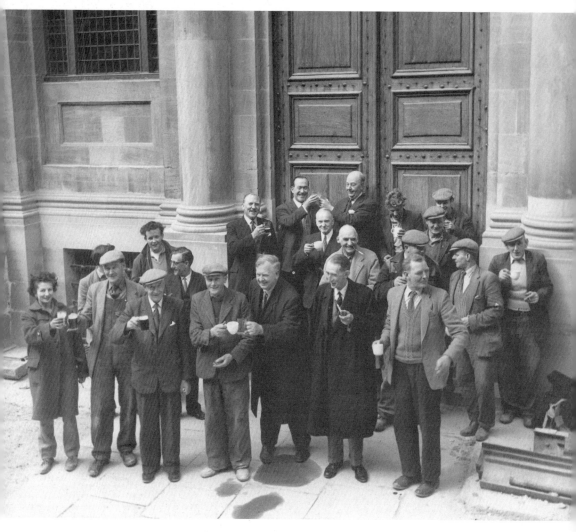

The Sheldonian Theatre, ceremonial hall of Oxford University, was in such a bad condition that it had to be closed from 1958 to 1963 for essential restoration work. Under the control of local building firm Benfield & Loxley, this involved the combined skills of architects, surveyors and builders, stonemasons and carvers, gilders and decorators, glaziers and woodcarvers. When the work was finally completed, those who had taken part gathered outside the Sheldonian in March 1961 to toast their achievements.

In 1714 a monumental mason called Osborne set up in business in his home village of Stonesfield. The business moved to Oxford and in 1967 the firm of Osborne & Son exported their first order to America after a visit from a couple whom William Osborne had met on a boat home from America. They were captivated by the gravestones being engraved and promptly ordered one for themselves to be erected in a cemetery in New York State.

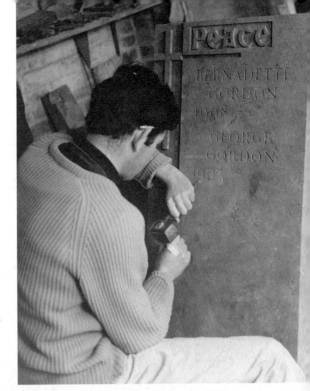

This silk screen workshop was reached down a narrow passage in King Edward Street, off Oxford High Street. The silk screen process was invented in China 3,000 years previously using rice paper and human hair. The workshop owner, Ray Milton, was the only craftsman practicing in the county in February 1959 when this photograph of apprentice John Wardrop was taken.

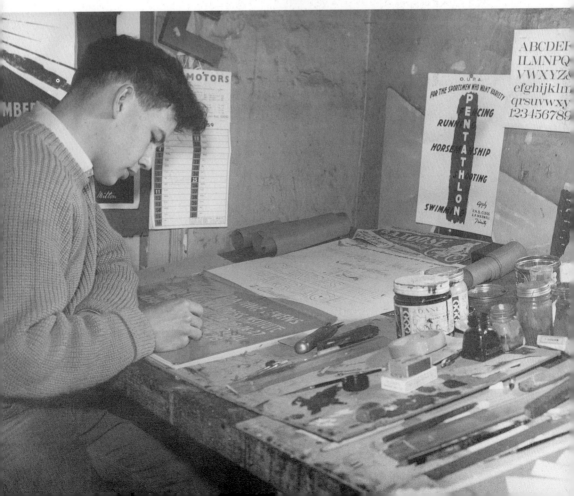

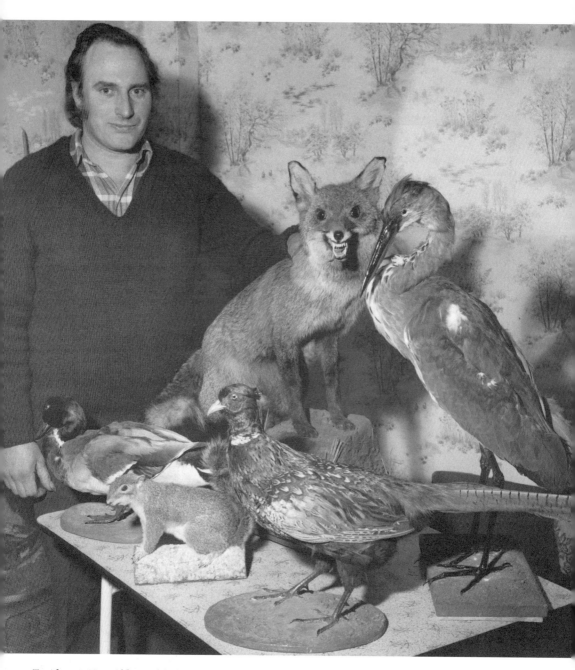

Taxidermist Jon Aldsworth's first attempt was a green woodpecker, which was not a huge success, but he persevered and graduated to a squirrel, then a duck and a magpie followed as his technique improved. By the time this photograph was taken, he was being contacted by gunsmiths with requests to stuff a whole range of birds and animals.

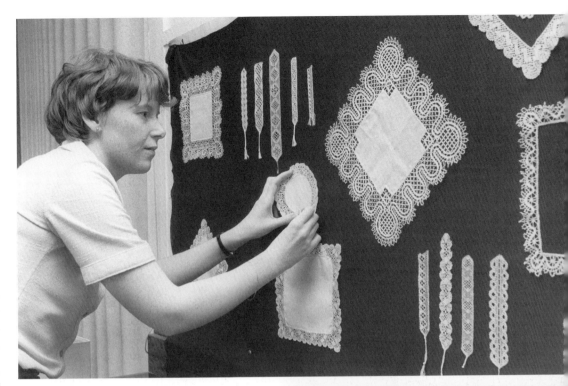

The Oxfordshire area, along with neighbouring Buckinghamshire, has a long tradition of lace-making. Apart from the beautiful end products, the attraction of lace-making was that it could be carried out in the home while childminding. Although handmade lace has been largely superseded by the machine-made variety, courses are still run and displays, such as this one by Christine Yeoman in April 1981, can be seen at fairs and shows.

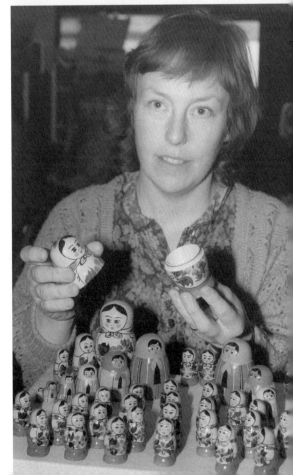

A much less traditional craft, at least in Britain, is the carving and painting of Russian dolls. Andrea Nelson, who showed her dolls at the John Radcliffe craft fair in November 1982, was in good company for there were also leatherworkers, glassblowers, wood-turners and jewellers. Many of the craftsmen were disabled and had gone on to make a livelihood out of a hobby.

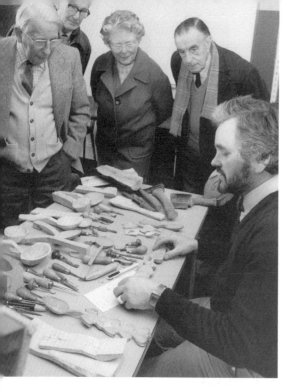

An alternative to Valentine cards is the Welsh love spoon. Head of Design at the Cooper School in Bicester, Welshman Peter Lister, who was also an expert carver, spent two days at the County Museum in Woodstock demonstrating his art in February 1983. Love spoons date back over 300 years and were carved by young men to give to their sweethearts as a token of love.

One product which is instantly recognisable is the British Legion poppy in all of its various forms. At the British Legion fête at Hanney, branch secretary Mike Lambel and chairman Gerry Newman watch James Carlin demonstrate the art of poppy-making. With them is 10-year-old Gary Belcher.

2

EDUCATION

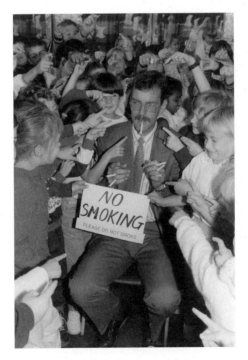

An unusual twist on the traditional headmaster-pupil relationship was featured in the *Oxford Mail* of 12 September 1990. Wally Ryde, Head Teacher at Bampton Church of England Primary School, was notorious for sneaking out and having a sly puff in the school bike-sheds. He is shown being mobbed by youngsters in an attempt to shame him into giving up smoking for good. The money saved by Mr Ryde from not buying cigarettes was donated to the Oxford and District Children's Heart Circle, based at Oxford's John Radcliffe Hospital.

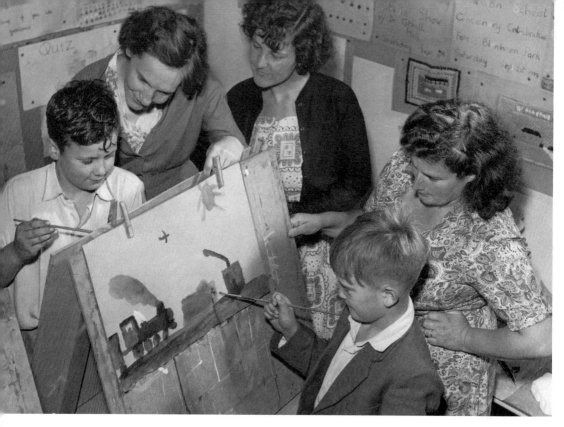

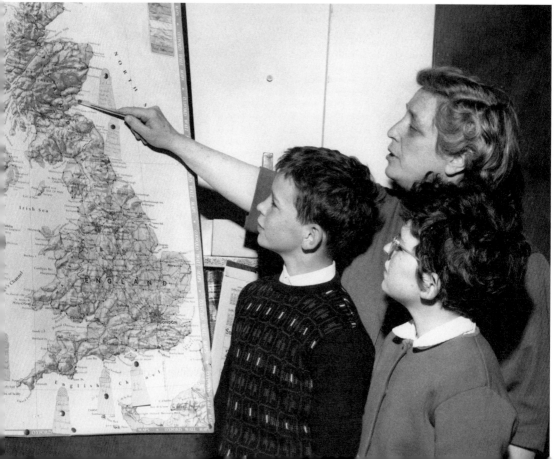

In the summer of 1961, Great Tew Infant School teacher Mrs J. Hall and her seventeen charges grew a giant potato plant which reached a record height of 7ft 1in. It started off inside the classroom but kept being knocked over. Mrs Hall was about to leave Great Tew for another post at Stonesfield but before she moved on she and the children planned to explore underneath the plant and see what potatoes it had produced.

Opposite above: In September 1958 Bladon School held a week of centenary celebrations. These included a presentation of the school's history in which generations of former pupils took part. The last event was a fête in Blenheim Park. Shown admiring pupils at work are Nigel Morgan, Mrs T. Pearce, Mrs R. Nappin, David Nappin and Mrs G. Morgan.

Opposite below: Two very different worlds met in May 1965 when pupils at St Thomas the Martyr and South Oxford Schools were joined by a number of children from Stevens' travelling funfair, which was at the Oxpens for the week. Headmistress of St Thomas's School, Miss C.E. Weston, shows Peggy and Perry Stevens some of the places which they have visited while travelling with the fair.

July 1983 marked the end of Mrs Ruby Horne's twenty-nine-year stint as a caretaker at Clanfield School. Her own three children were pupils there, as were many of the parents of the children in this photograph. When Mrs Horne started work there were just two classrooms, but when she left there were four, with eighty children.

Opposite above: This wreath was presented to the County Council on behalf of the Oxfordshire branch of the National Association of Teachers in Further and Higher Education at a demonstration by the county's teachers in February 1977. Shown carrying the wreath are Di Parkin and Peter Cowperthwaite.

Opposite below: Hundreds of teachers marched along Cornmarket Street during a pay protest in February 1986. Members of the National Union of Teachers had walked out of lessons the previous afternoon. This caused schools to close and children to be sent home early. The march, which had started with a rally in the Town Hall, went via Cornmarket, George Street, Worcester Street and New Road to reach County Hall.

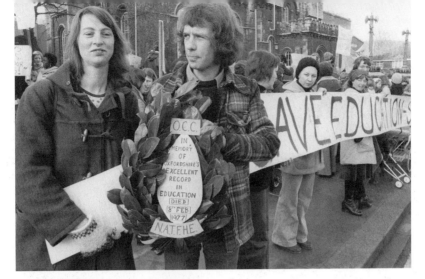

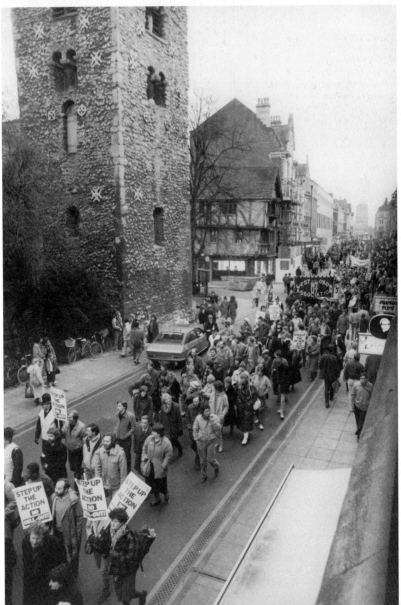

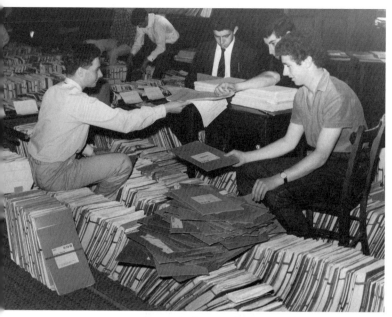

The University of Oxford had its own examination board, the Oxford Local Examinations Delegacy. During the Long Vacation it employed more than 350 temporary workers to deal with the CGE examination scripts and outgrew its Merton Street premises and had overflowed into the University Examination Schools. Therefore, in the early 1960s, work began on its new home in Marston Ferry Road. In this photograph, taken in August 1964, casual workers sort and check the scripts in the Schools.

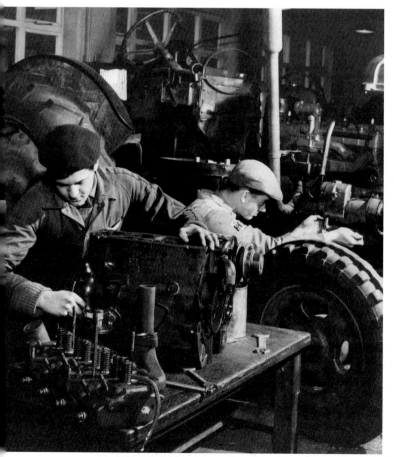

Rycotewood College for Rural Crafts was founded on the site of the former workhouse and incorporated some of its buildings. In the late 1950s it was taken over by Oxfordshire County Council as a residential technical college, specialising in agricultural engineering and carpentry. A.V. Laundon and R.M. Heard are seen busy at work in the power unit shop in December 1961. In 2003 Rycotewood became part of Oxford and Cherwell College but it closed soon afterwards and was turned into an upmarket housing development.

Students on the first Home Office Preliminary Certificate Course in Child Care at North Oxfordshire Technical College set a record in the summer of 1969 when they achieved a 100 per cent success rate. The girls seen here are Joyce Buzzard, Jane Bowerman, Joan Beachley, Diane Green and Gloria Bateman.

This undated photograph was taken in around 1960 outside the university's Examination Schools in the High Street. These students are patiently waiting to be admitted to sit their examinations. Full academic dress is obligatory and those wearing ordinary clothes are well-wishers who have come to offer moral support.

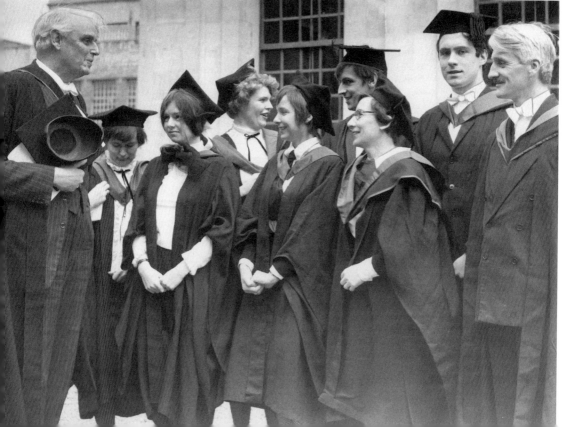

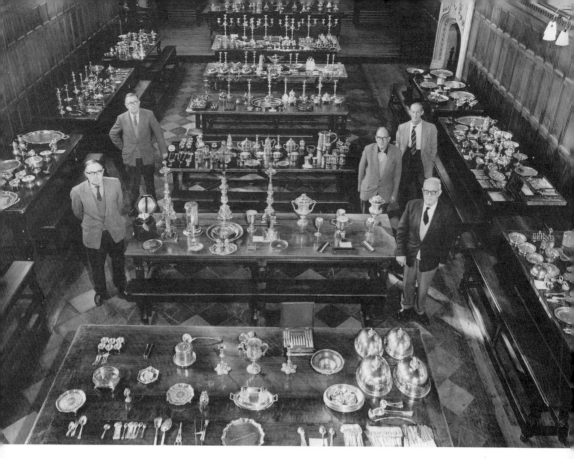

Tables set out with the impressive collection of silver for the annual inspection by the bursar of Pembroke College in October 1964. The oldest items in this collection date from the mid-seventeenth century; like virtually all Oxford colleges, Pembroke had to surrender its medieval plate to be melted down for the use of the King during the Civil War.

Opposite above: This picture of undergraduates celebrating after finishing their exams tells quite a different story. It was taken in February 1965, not in the main examination period — which is at the end of Trinity Term from May to July — so they may have been retaking exams. Nowadays candidates and their supporters are not allowed to gather in the High Street as they traditionally did, but must leave the building under strict supervision by either of the Merton Street gates.

Opposite below: The end result of all this study and examinations is, of course, the conferral of degrees. Ceremonies take place in the Sheldonian Theatre throughout the year, not just after exam results are published, and candidates can choose which one to attend. These graduands, who were Oxford's first Bachelors of Education in November 1969, are shown with Mr A.D.C. Peterson, Director of the Department of Educational Studies.

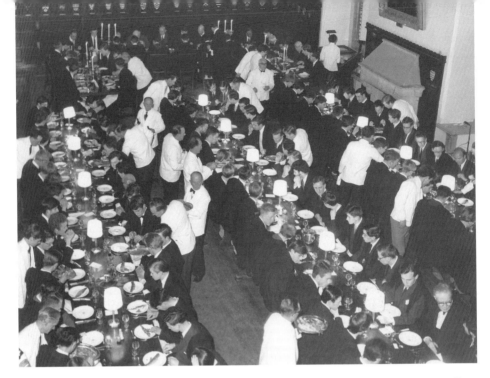

An overhead view of most of the guests at the septencentenary dinner held at Merton College in May 1964 during the 700-year anniversary celebrations, which lasted a week. The college was founded by Walter de Merton and is one the three which can claim to be the oldest in the university, the others being Balliol and University Colleges.

Back at Merton in February 1977, with head chef Paul Brothwood (who measured 5ft 4in), standing on a box and wearing a tall hat. This was his way of getting level with Bob Mason, President of the Oxford University Boat Cub, who measured 6ft 5in. Paul is shown with stroke Andy Michelmore and a tray of steaks given by Dewhursts the butchers for the Oxford crew taking part in the University Boat Race that year.

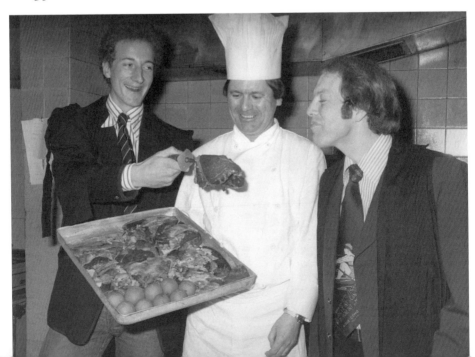

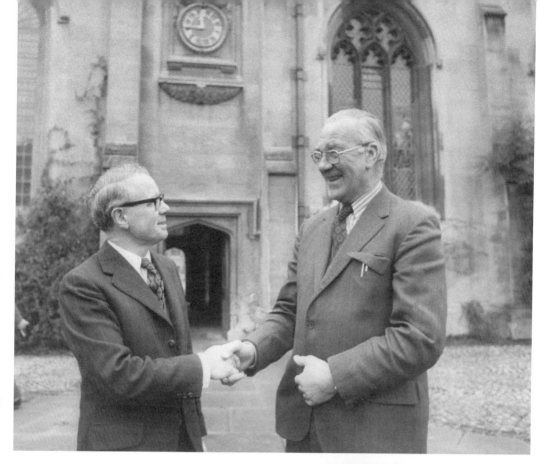

Two pillars of the staff at St John's College on the eve of retirement in December 1976. Pictured wishing each other all the best for the future are Steward Ronald Hancox and Head Porter Dick May who left the Central School at 14 and went to work in the buttery at University College but afterwards went on to work at St John's for forty years.

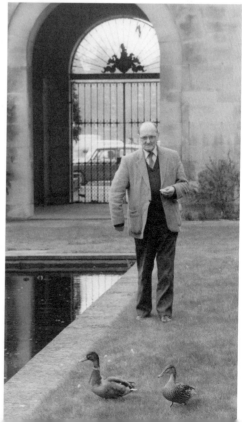

Nuffield College used to be visited each spring by a pair of mallard ducks, who made their nest in the shrubbery and raised a brood of ducklings on the college pond. Porter Melbourne Tomlin is shown with Sidney and Beatrice in March 1986, shortly after they arrived for their fifteenth season.

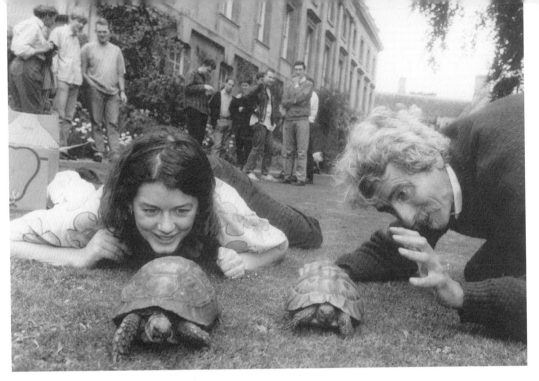

College gardeners are the lords of their own little domains but occasionally they have to welcome outsiders. David Leake, head gardener at Corpus Christi College, is shown in May 1993 at a crucial point during the annual Tortoise Fair. With him are Kitty Ussmer of Balliol and college tortoise, Rosa Luxemburg, while David is urging on the Corpus entrant, whose name is sadly unrecorded.

The world of education is not always a tranquil one, however. These pickets guarding the gates of Pembroke College in the summer of 1980 were clearly angry at what they saw as unfair pay. The *Oxford Times* reporter pointed out that it was the college's 'first industrial dispute in 356 tranquil years.'

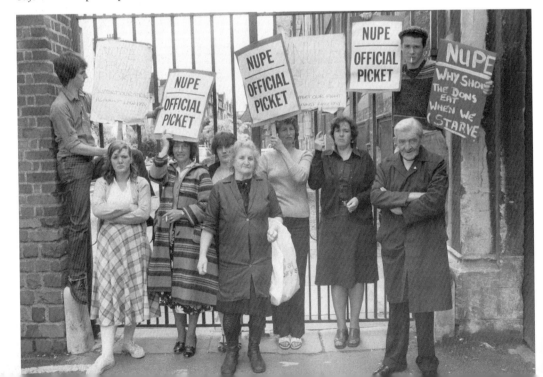

White-coated laboratory technicians carrying out tests on a little-remembered essential in the printing and publishing industry at Flexographic Inks in Thame in October 1960.

Another view of the less glamorous side of book production, taken in 1960 as part of the production of ink at Flexographic Inks, shows that it was heavy, dirty and potentially dangerous work.

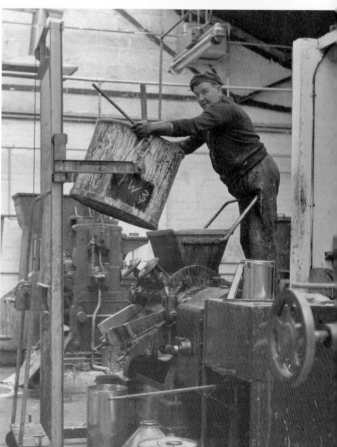

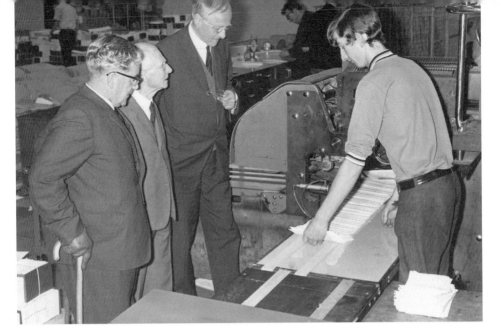

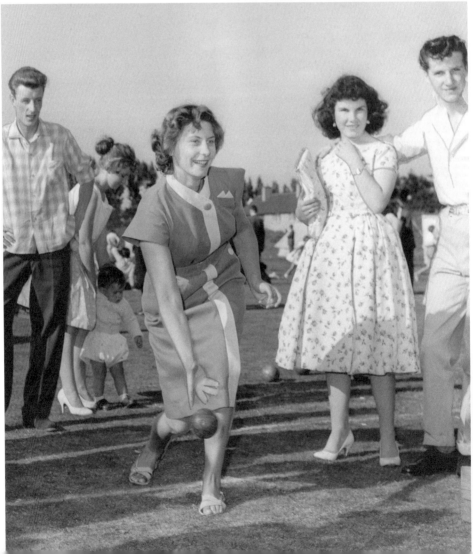

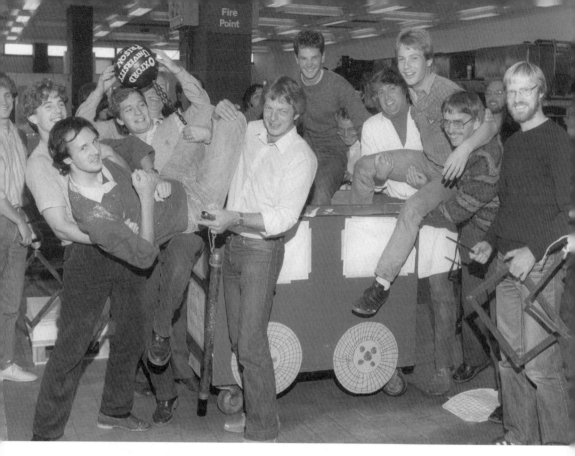

It was the end of an era at the OUP when its last three apprentices to be trained in the traditional way graduated in September 1984. Originally lasting seven years, the apprenticeship had already been reduced to four. Shown about to embark on an unceremonious tour of the printing works in a trolley are Martin Honey, Ken McMahon and Stewart Glenister.

Opposite above: Professor W.D. Hardy, Dr C.H. Dodd and Professor Sir Godfrey Driver, translators of the New English Bible, watch copies being printed on a web-offset press at the Oxford University Press in February 1971.

Opposite below: Oxford University Press workers formed a sort of family group, with a housing estate, Jordan Hill, just to the north of the city. Mrs M. Morgan is shown here trying her hand at skittles at a sports day in September 1959.

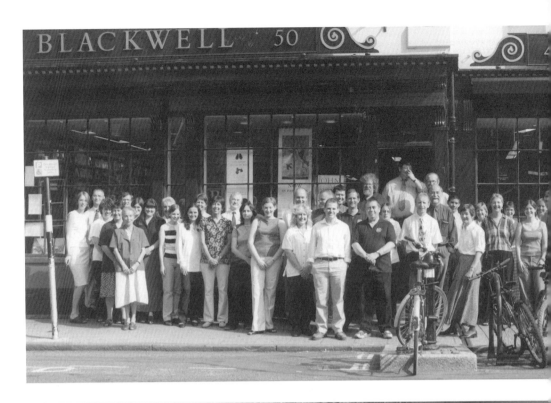

Left: The staff of Blackwell outside their main Broad Street bookshop in March 2002. The first publication from booksellers B.H. Blackwell appeared in 1897 and in 1922 a separate publishing house was set up in Oxford as Basil Blackwell & Mott. Early twentieth-century Blackwell authors included W.H. Auden, Graham Greene, Enid Blyton and J.R.R. Tolkien, but after the war emphasis changed to educational publications. Today there are more than fifty Blackwell shops countrywide, many of them on university campuses. Blackwell's main bookshop in Broad Street is made up of four old shops — all Grade-II listed buildings. There is also an extensive basement which stretches under part of Trinity College next door.

Left: These books were to be found in a much less obvious location, the library of Oxford Prison, in February 1982. The prison service offers a range of courses, some of them designed to equip the inmates for the outside world as well as providing more leisurely reading material.

Right: Diana Yonge and Marion Softley are shown in April 1996 dressed in Victorian costume to mark the centenary of the Abingdon Library's opening. The present library is housed in a modern red-brick building in the Charter, but there is a stone marking the site of the town's Free Library, which opened in 1896 in a building in the High Street, opposite West St Helen Street.

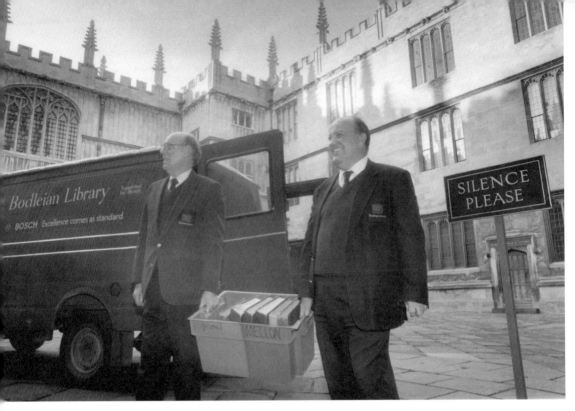

Ray Bradbury, Head Porter at the Bodleian Library, and porter Eric Fry unloading books from the library van, which had been sponsored by Bosch. 'The Bod' is one of six copyright libraries in Britain and Ireland which are entitled to a copy of every book published in the country, which means an ongoing need for expansion.

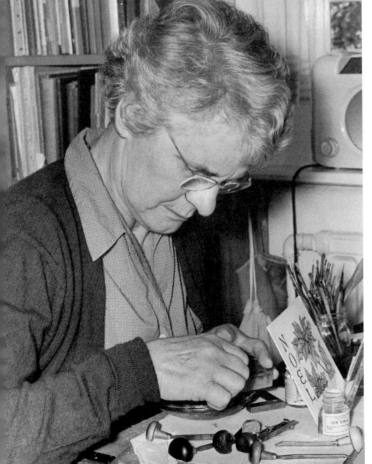

The Cocklands Press, which was based in Burford, specialised in producing individual high-quality artwork. Pictured here in July 1962, Miss Helen Bryce is concentrating on a wood engraving, using tools and traditional materials such as ox gall.

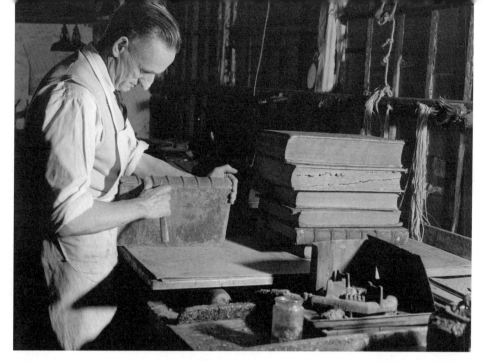

Some larger libraries like the Bodleian have their own binderies, but the private book-binding and repairing business Maltby's the Bookbinders is an Oxford institution. Since it was established in 1834, generations of students have taken their theses to their St Michael Street premises to be bound. When these closed, Maltby's relocated to Pony Road on the city outskirts. In this photograph, taken in November 1958, a craftsman is repairing a set of ancient leather book-covers.

News-vendor Winifred Denton sold the *Oxford Mail* on the same pitch on the corner of Magdalen and Cowley Roads each weekday for fifteen years. When she retired in March 1968, her customers presented her with a bouquet and a pair of slippers.

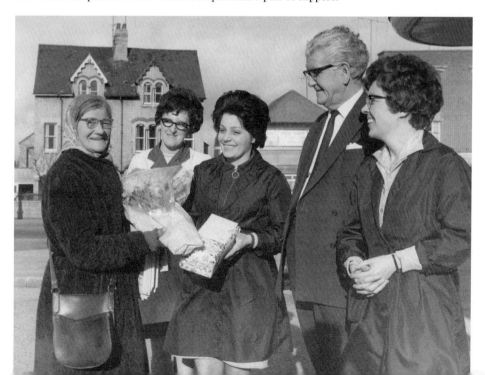

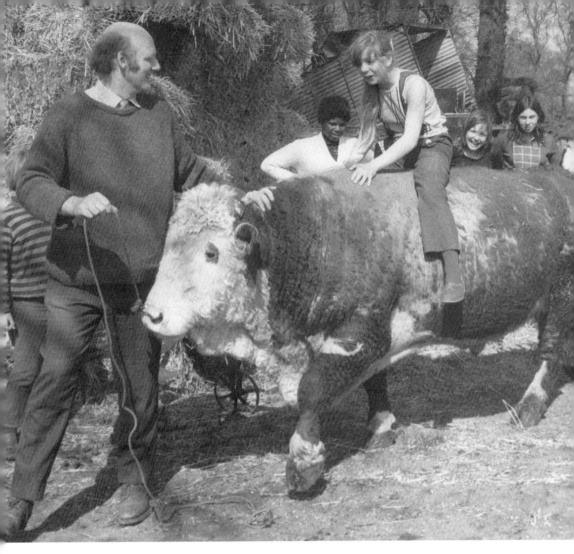

Children from Starcross School, Islington, visited three farms in the Wantage area in April 1973 for a taste of life in the country. At Tulwick Farm, Grove, 14-year-old Susan Stockton jumped at the chance to ride a prize bull under the watchful eye of Dr Richard Squires.

Opposite above: In October 1967 the *Oxford Mail* reported that Oxfordshire had 'exceptionally good facilities for farm training and education.' These students are admiring pigs at the County Teaching Farm at Albury, near Thame.

Opposite below: Education is not confined to book-learning, as these young men attending a course at Waterperry Horticultural School found out in March 1965 as they watched Miss M. Spiller demonstrate pruning. In 1932 the school was opened by Beatrix Havergal as a residential horticultural college for women. When Miss Havergal retired in 1971, the house was taken over by the Fellowship of the School of Economic Science and is now a horticultural and garden centre. The school hosts the annual 'Art in Action' festival in July, where craftsmen and women from all over the world demonstrate their skills.

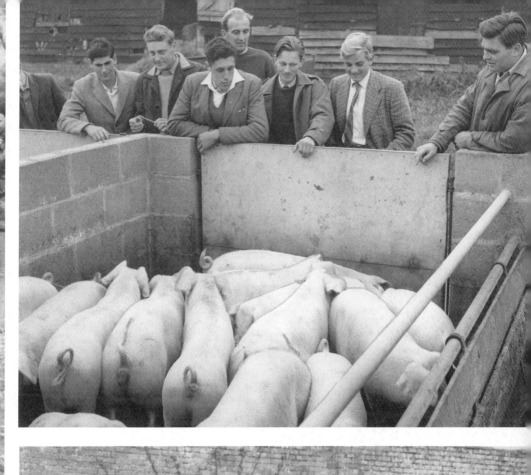

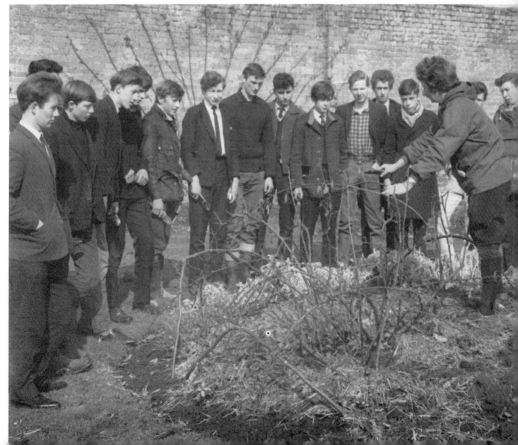

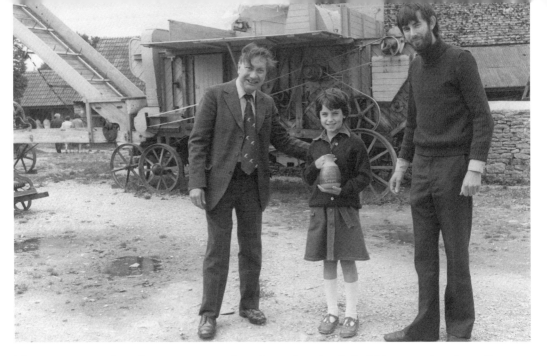

There are more than forty museums of various sizes in Oxfordshire, ranging from the multi-million-pound Ashmolean to tiny collections staffed by volunteers. This is Cogges Manor Farm Museum, Witney; a 20-acre working museum clustered round an ancient manor house. Eight-year-old Sarah Carr (shown here with Director of Museum Services James Bateman and Curator Chris Page) was its 50,000th visitor in August 1979 and was presented with a pottery jug, followed by a cream tea for all the family, to mark the occasion.

George Swinford, curator of Swinford Museum, which he founded in the 1930s, is pictured here in December 1974. The clay pipe, which belonged to his father, is displayed by Mr Swinford with a selection of candles and snuffers. This 'fine collection of local domestic, agricultural, trade and crafts tools' survives as one of the county's oldest and smallest museums and is housed in a seventeenth-century cottage at Filkins.

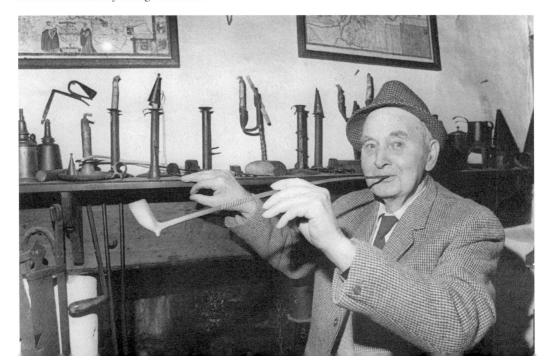

3

SERVICES

In 1984 six officers from Oxford Prison planned a break-out in aid of
LEPRA, the British Leprosy Relief Association. They appeared in the local
press to appeal for a wealthy sponsor to help them flee the country, hoping
that a millionaire or a firm might come forward to pay their travelling
expenses. Shown here on the lookout for a backer are Mathew Cunningham,
Chris Ponting, Dick Ellis, Barry Jackson, John Williams and Fred Welch.

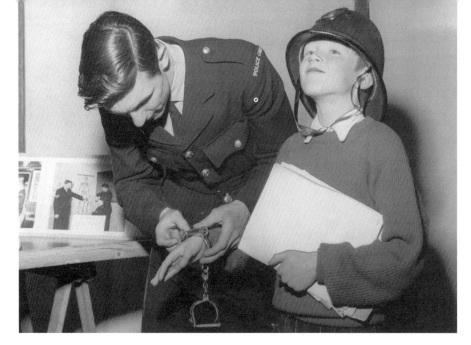

The County Police Force had a stand at the Oxfordshire Show in May 1962 where the public could come and find out more about the work of the local police. The young visitor in this photograph jumped at the chance to find out what it would be like to wear a pair of handcuffs, although the police helmet was a little on the large side.

Police dogs make an important contribution to the force's work and black Labrador Busby was a fine example. He used his hyper-sensitive nose to sniff out certain substances with the help of his handler, Sergeant John Moore. In April 1990, 10-year-old Busby changed his police kennel for luxurious retirement in the home of his new owner, Mrs Eileen Lomas, at Stonesfield, where his most strenuous duty would be a leisurely stroll round the village.

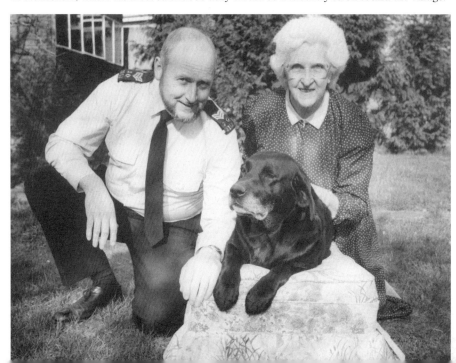

HM Inspector of Fire Services, Mr F. Dunn, visited Thame in July 1963. He chatted with the men on parade when he carried out an inspection of some of the fire-fighters of Oxfordshire. The helmets are more reminiscent of those worn by members of the Home Guard and ARP wardens than the usual, more elaborate, headgear.

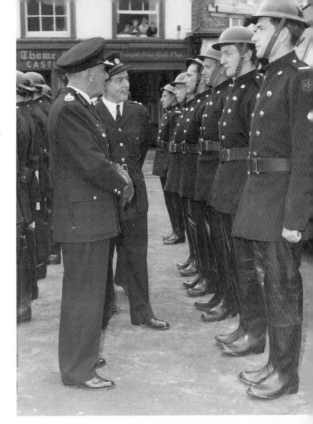

In March 1966 a new fire station was opened at Witney in Welch Way. Shown here posing on what was then an up-to-date appliance parked in front of the new premises are members of the town's fire-fighters, led by Station Officer Wright, who is wearing the white helmet.

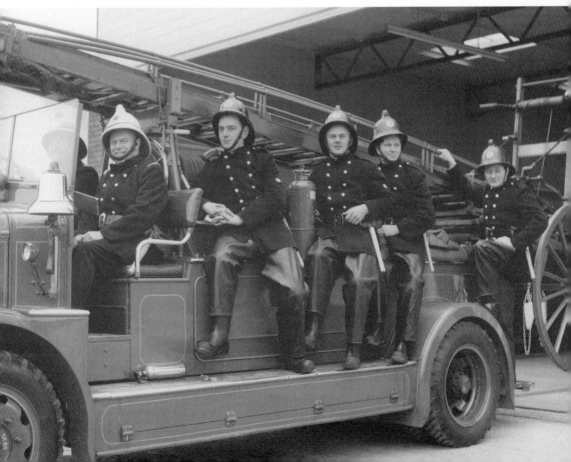

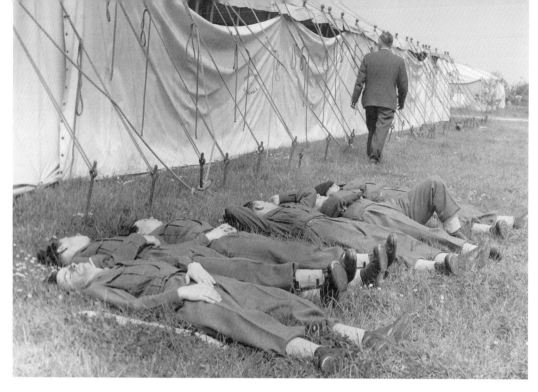

Agricultural shows such as the Oxfordshire Show feature displays by teams from all the military and emergency services. These demonstrations, which include pipe bands, dog-handling and motorcyclists, usually take place in the main ring and in May 1961 one of the star turns was the Royal Army Ordnance Corps. These six soldiers took the chance of forty winks outside one of the show tents.

Servicemen were allowed to eat out of uniform in the dining room at RAF Benson in a bid to raise morale at the base. Wearing plain clothes was one of a series of relaxation of restrictions which were introduced in 1958 as an experiment to make service life more cheerful.

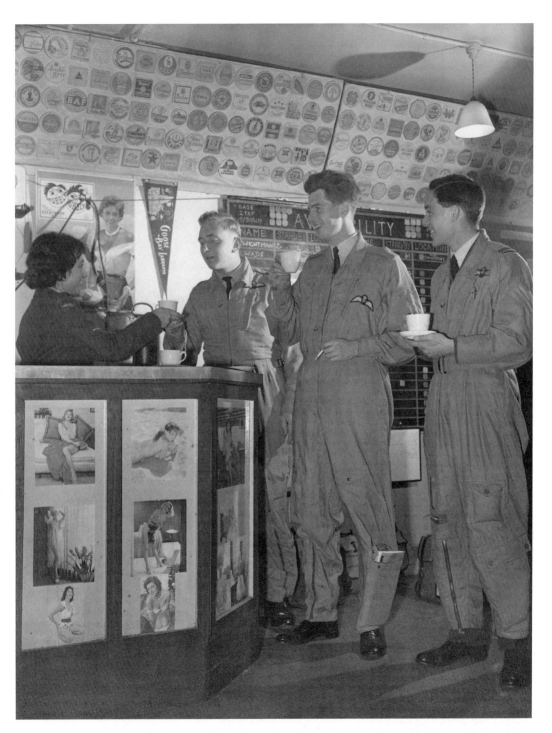

Having a goodbye cuppa in the tastefully decorated crew room at RAF Benson are these airmen preparing to leave on a 3,500-mile journey in December 1959. A flight of Hunter jets, accompanied by a Canberra, were pioneering a new route across the Sahara on their way to the Middle East. They were living up to Benson's 'reputation as the supreme specialists of route planning.'

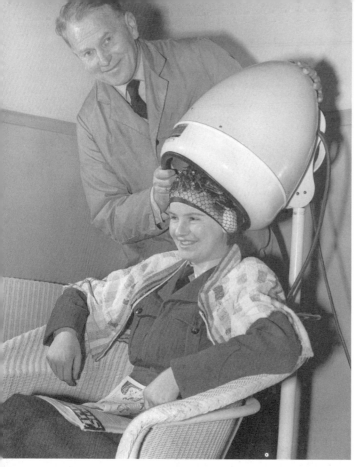

Still in uniform but being pampered nevertheless is this airwoman who appears to be enjoying her weekly hair-do at RAF Benson in February 1958. This was another part of the RAF's plan to help its personnel settle in and feel more at home by letting them lead a more normal life.

Taken in October 1976, this photograph of Flt-Lt Trevor Newton shows him in what was then the largest aircraft cockpit in the world. This was one of ten Belfast aircraft, the only ones in the world, which were based at RAF Brize Norton for ten years before they were axed in defence cuts that year. This single survivor at Brize was used as a demonstration model and Flt-Lt Newton was the last captain of a Belfast.

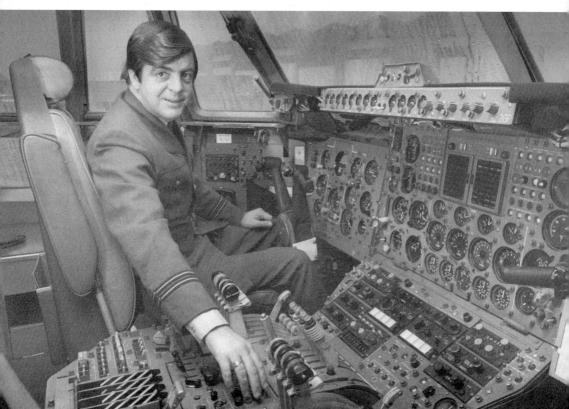

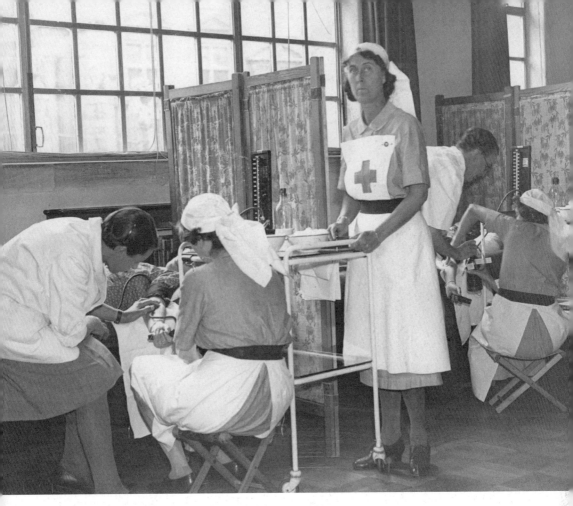

This undated photograph was taken in the New Bodleian Library where the canteen had been transformed into a blood donor session. A couple of doctors are in attendance, along with nurses in starched caps and aprons, complete with red cross, who had yet to be replaced by today's teams of specialised phlebotomists.

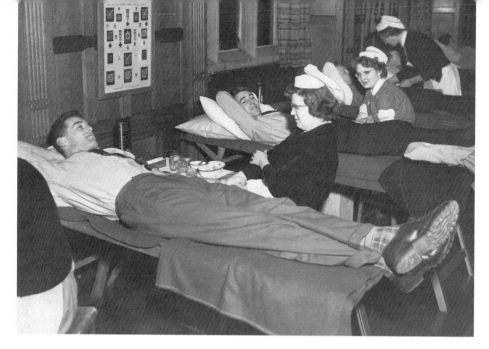

More blood donors and more starched uniforms, this time at the Police Training Centre at Eynsham Hall. The Oxford Unit of the Blood Transfusion Service visited the hall every three months and on this occasion in February 1958 there were 118 donors. The Service praised the police officers who donated about 50 gallons of blood each year.

When the City Workhouse closed, the premises were converted into Cowley Road Hospital for the elderly. Shown here with Viscountess Parker are Matron Miss K.M. Leaper and some of the nurses who were awarded certificates at the prize-giving ceremony in December 1961. The hospital itself closed in 1980 and the site was developed to include a health centre and the central mosque.

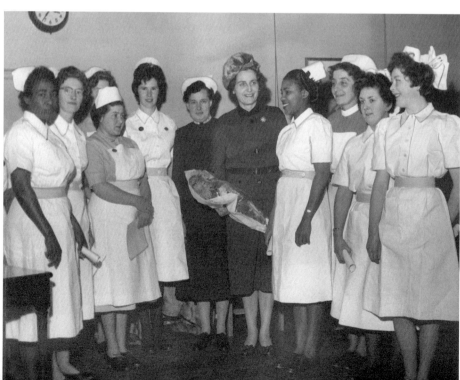

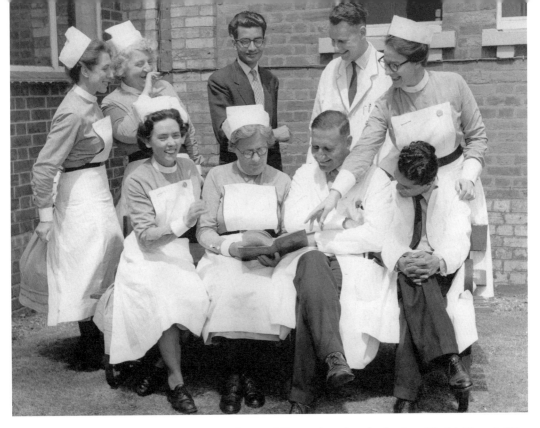

In 1961 Sister Dorothy Bartlett of Cowley Road Hospital produced a book entitled *A Nurse in War*, which is a description of her war service during the Second World War. This began when she joined the Territorial Army Nursing Service in 1939 and went overseas, first to France, then on to Iraq and Egypt. She gave up her commission as Senior Sister in 1945. Sister Bartlett is shown being congratulated on her achievement by her hospital colleagues.

Despite the fact that Cowley Road Hospital closed in 1980, its laundry service continued to handle in excess of 75,000 items every week from the John Radcliffe and Slade Hospitals. When the laundry closed in June 1982, the work was transferred to Berkshire. In the photograph is laundry assistant Rod East.

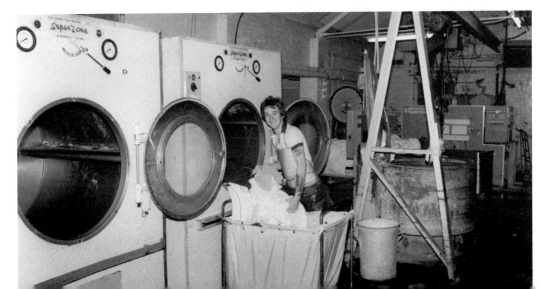

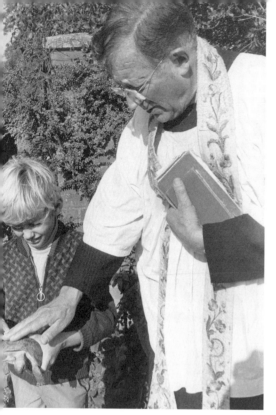

Village clergymen are called on to perform a variety of duties and here is the vicar of Blewbury, the Revd Hugh Pickles, in an unusual role. With him are Philip Richardson and his tortoise, which looks as if it would prefer to be elsewhere. Philip was among twenty pet owners who brought their cats, dogs, guinea pigs and tortoises to the annual animal service at Ashbrook House, Blewbury, to be blessed in October 1985.

This undated photograph was taken in the post office in the little village of Lewknor at some time during the Second World War. It shows schoolmistress Mrs Scott paying in her children's National Savings for the week. The poster urging customers to Save for Victory is very prominent and there is a similar one to be seen to the postmistress's left.

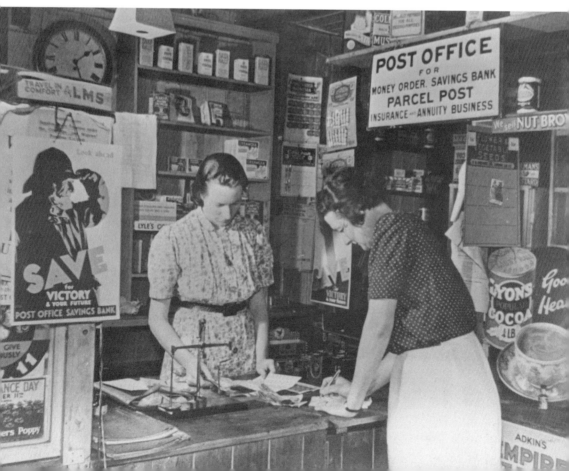

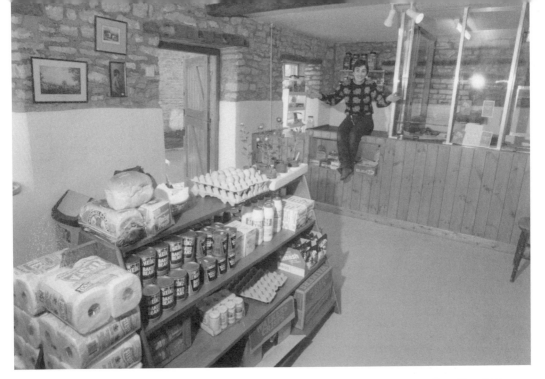

For four years the village of Over Norton had to do without a proper post office. The 500 or so residents finally got a new one in a shop which farmer Ian Pearman and his wife Rebecca converted from a stone barn, which had last been used as a pig sty. Mr Pearman, of Firs Farm, is pictured sitting on the counter of the new shop.

The sorting office at Becket Street in Oxford, March 1971, after the forty-seven-day postal strike had come to an end. Sorters are shown trying to clear the backlog, which included letters posted on 20 January. The Head Postmaster believed that nearly all the staff had returned to work, although he knew that some had found other jobs during the strike.

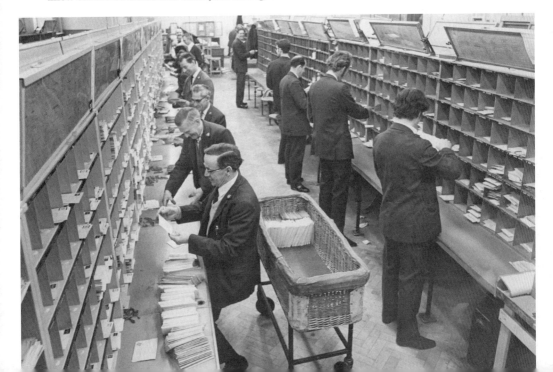

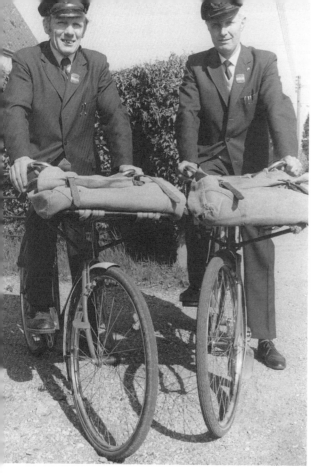

Left: By May 1984 two Cumnor postmen, Jim Adams and Tony Marks, had delivered upwards of a million items of post to 600 homes in their twenty-seven-year partnership. So highly did the community think of their helpful ways that a testimonial fund was set up for them when they were forced to give up their rounds, which were discontinued when the mail started to be delivered from Oxford instead of from Cumnor post office.

Right: A traditional dish — which was described as a 'show-stopper' at the Oxfordshire Show in 1970 — was this boar's head displayed by Patrick Delaney, chef at New College and Master of Oxford City Guild of Chefs. It was one of a number of banquet dishes which formed part of the British Farm Food Fair. A similarly decorated boar's head has appeared at Christmas celebrations at the Queen's College for centuries, and has its own carol to accompany it.

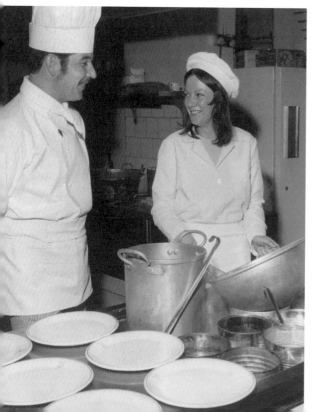

Left: Nineteen-year-old Jill Bower, a pastry-cook at Banbury's Whately Hall Hotel, was toasted by her colleagues when she completed a four-year City and Guilds catering course at North Oxfordshire Technical College in only two years. The hotel's managing director presented her with three cookery books and a set of kitchen knives. She is pictured here with head chef Roy Poyser.

Right: The fact that the county attracts a huge number of visitors every year is sometimes overshadowed by the importance of the tourist trade in the city of Oxford itself. Much of the accommodation in the countryside is similar to this bed and breakfast, where Mrs Janet Rouse serves breakfast to guests at her Bampton home in 1992.

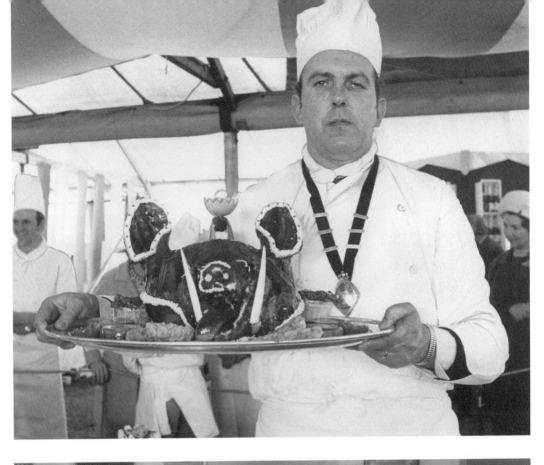

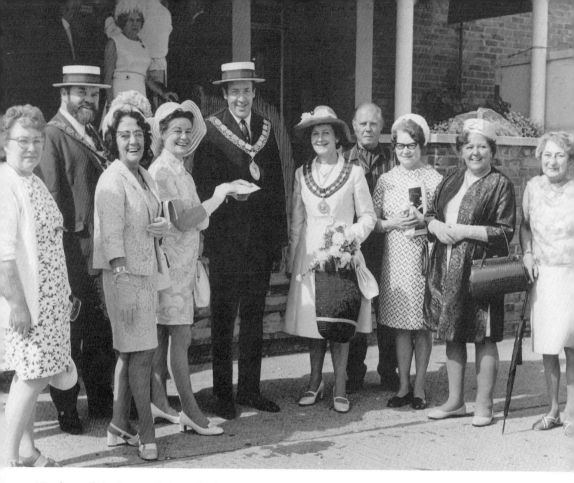

Members of the Licensed Victuallers' Association Women's Auxiliary of Witney and their friends gathered together in their summer finery to pose for this photograph. They included representatives from the Elm Tree in Witney, the Lord Kitchener in Curbridge, the Bull in Aston and the Marlborough Hotel. Wearing chains of office and boaters are Mr F.S. Patterson, chairman of the Licensed Victuallers' National Homes, and their president, Mr J.H.N. Porter.

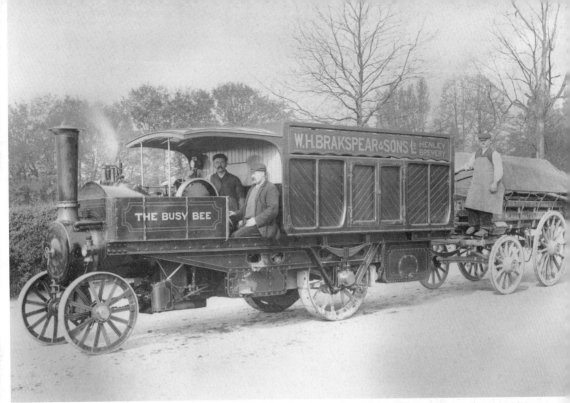

For communities used to seeing beer delivered by horse-drawn drays, the Busy Bee, used for deliveries by W.H. Brakspear & Sons' Henley Brewery, must have seemed the height of modernity as it chugged its way round south Oxfordshire at the turn of the twentieth century.

Frank Wilkinson of Burford turned a hobby into a living when he took over a historic brewery in Sheep Street, Burford. His connection with the brewery began when he left the grammar school nearby to become an office junior in Garne's Brewery. Moving up the ladder, he eventually became managing director. He is shown here in January 1966 passing on his expertise to his son Stephen, in this case a bottle of Burgundy.

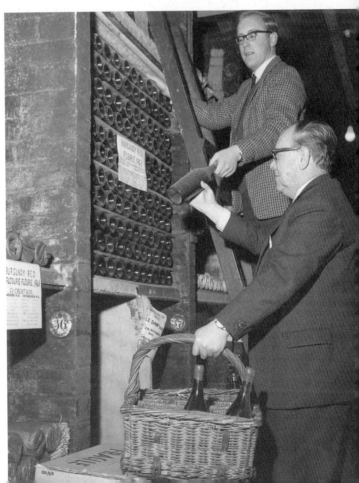

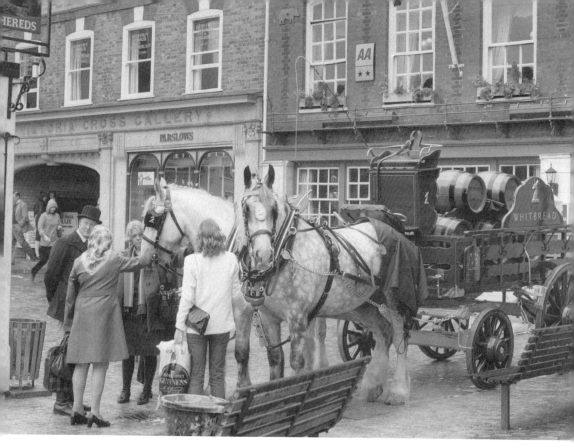

The same horses which had earlier drawn the Lord Mayor's coach through the streets of London pulled the dray on to the forecourt of the Bear Hotel in Wantage in December 1981. The Bear had recently changed to the Wethered Brewery and the beer arrived complete with footmen. Afterwards the team gave local children rides round the Market Place.

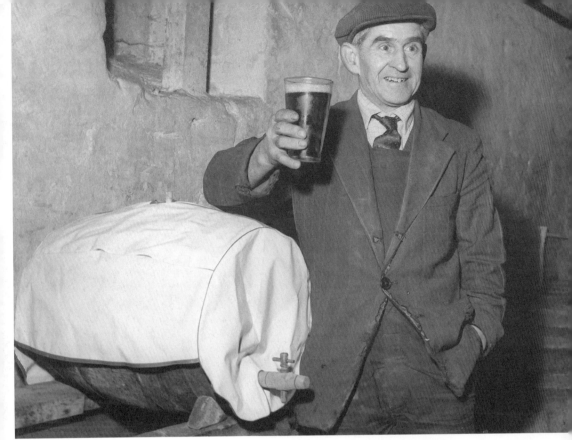

One of the perks of working for Garne's Brewery in the mid-1960s was the 9-gallon cask of ale which stood in the cellars. Any brewery worker was allowed to help himself whenever he felt like it 'in accordance with ancient custom,' and by the look of it this employee at least was very happy with this aspect of his working life.

This photograph, taken in October 1960, is reminiscent of the days when beer was made at home and served in the front room. Mrs A. Haynes, wife of the landlord of the Falkland Arms in the village of Great Tew, is shown filling a glass with beer carried up from the cellar. The pub got the reputation of being haunted when unexplained shrieks and moans were reported there.

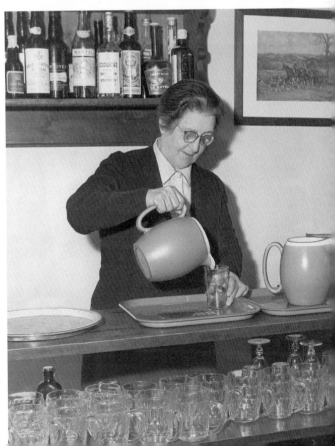

As befitted one of the town's leading employers, a Morland's Brewery float always formed part of the Abingdon carnival parade. This float, which appeared in June 1974, represented the interior of a Morland's pub as it might have appeared in the time of the painter George Morland (1763-1804), who is commemorated in the brewery's name and logo.

Although staff at Morland's Brewery in Abingdon got themselves a reputation for being foul-mouthed, their bad habit was turned into an advantage in August 1985. Each profanity resulted in a payment going into a swear bottle and when the bottle was smashed it was found that £71.65 had been collected. The chosen charity was multiple sclerosis research and this was the fifth time that a swear bottle had been filled for charity. Pictured are organiser Nola Griffin (right), trade director Chris Lowe and June Sparrowhawk.

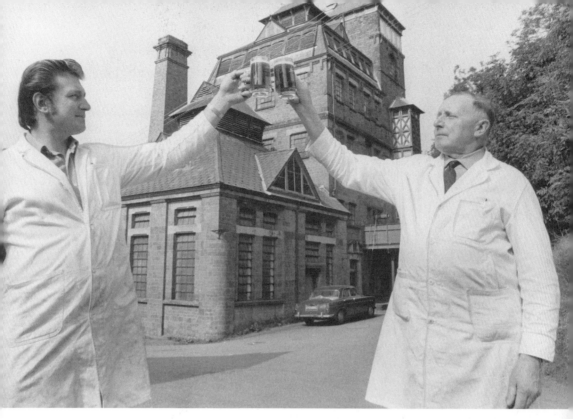

Hooke Norton Brewery, home of the celebrated 'Hookie' ales, was established in 1849. The founder's grandson, Bill Clarke ('company director and brewer extraordinary'), is shown offering up a brewer's toast with his own son, David. They are standing outside the brewery in October 1971, when it still had a Dickensian feel about it and was one of the smallest in the country.

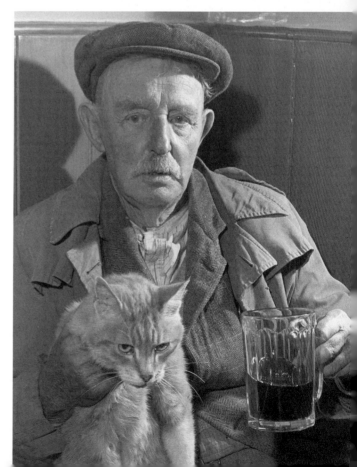

Retired steam-roller driver Mr Harry Lay was a regular at the long-vanished Farmer's Man at Benson, where he was photographed with a furry friend, the landlord's cat, in July 1960. For a grand total of forty-four years Mr Lay had what was at the time a young boy's dream job, driving a steamroller between Henley and Banbury.

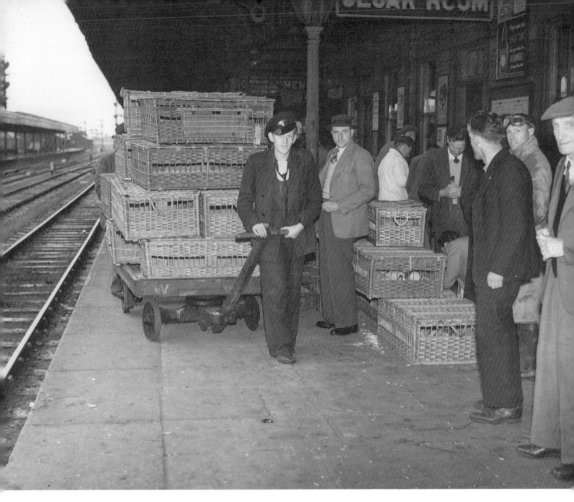

Oxford station in June 1955 – and not a train in sight. The wicker cases which the porter is pulling along on the trolley contain racing pigeons, which shows how popular the sport was at that time. The fanciers on the right of the picture are there to see that their birds are loaded safely, and at least one of them seems to find it difficult to say goodbye.

Opposite above: In June 1958 Harold Spindlow (on the left) retired as the local representative of the District Operating Superintendent, Paddington. He is shown taking his leave of colleagues who worked at Oxford railway station with him before the First World War. Pictured with Mr Spindlow are, from left to right, Mr J. Miller, the Oxford stationmaster, Mr P. Thomas, Mr F. Trafford, Mr E. Brentnall and Mr C. Bloomfield.

Opposite below: Hoping to offer a novel form of transport to visitors and locals alike was this carriage driven by Gerald Williamson, the owner of Abingdon Coaches. Mr Williamson was photographed in October 1980 following his application to the Vale of White Horse District Council for a hackney carriage licence to allow him to pick up fare-paying customers; no existing by-laws covered horse-drawn cabs in Abingdon.

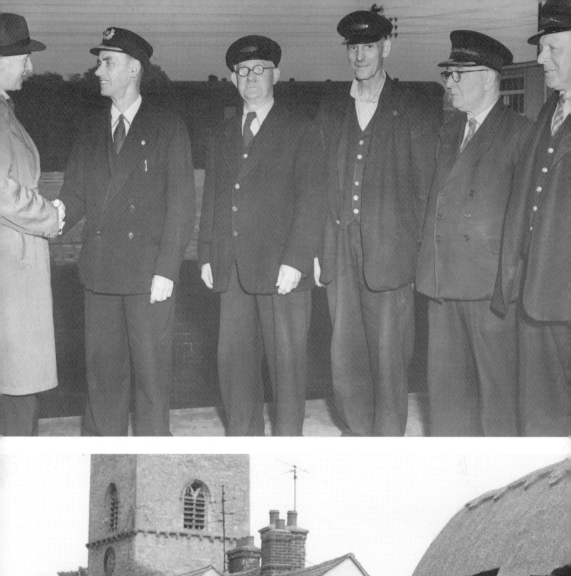

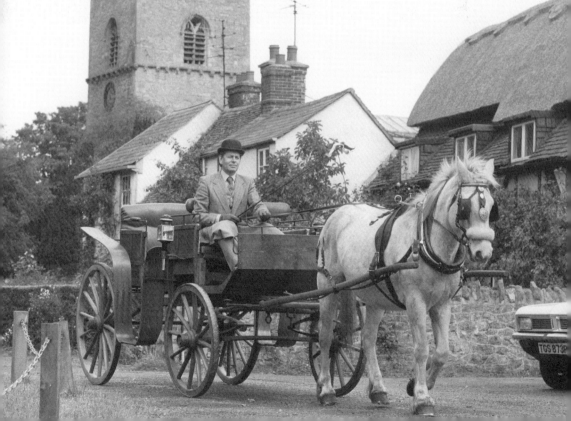

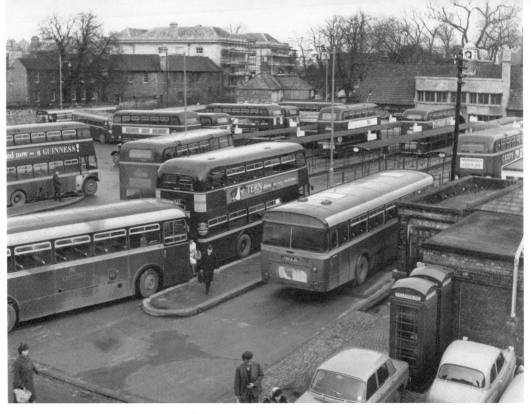

When this photograph was taken in December 1967, all country services ran from the bus station in Gloucester Green and a large proportion of them were the traditional red double-deckers. The building in the right foreground is a café constructed on the site of the city gaol and the one with the bell-tower in the background is the former boys' grammar school, at that time in use as a waiting room.

Men from the City of Oxford Motor Services garage on the Cowley Road gather around the cup they won for work on an award-winning bus. The poster on the side of the bus advertises a journey to London for £2.30, with a choice of three routes.

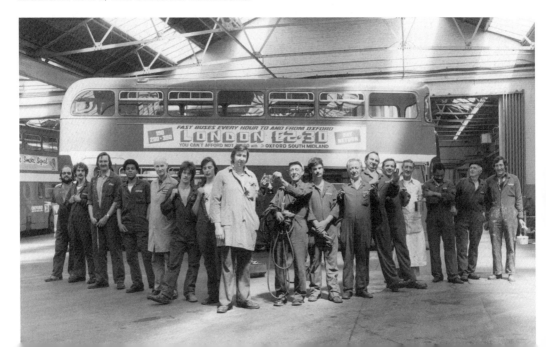

Some of the last conductors working on the City of Oxford Motor Services buses. Once every bus had a clippie as well as a driver but by December 1974, when this group was photographed posing on one of the double-deckers whose days were also numbered, the number had dropped to twenty-two, as opposed to 350 drivers, and one-man buses took over. Posing as 'the last of a dying breed' are conductors Madge Grant, June Allen, Jim O'Donoghue and Mary Doherty.

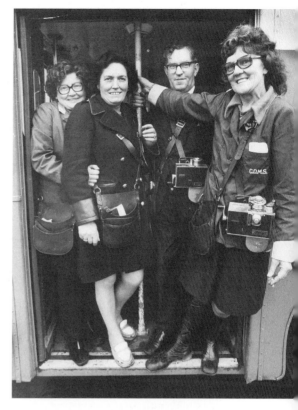

In January 1986 staff at the City of Oxford Motor Services managed to raise more than £3,000 for charity after twelve months of fundraising. They are pictured here with a computer, which they gave to Mable Prichard School for the Handicapped in Littlemore, and cheques (held by Mary Pickering and George Barnett) towards paying for a monitor at the John Radcliffe Hospital's special-care baby unit, and for holidays for youngsters at the Park Hospital. The money was raised by events such as raffles and auctions and taking part in the London to Brighton cycle race.

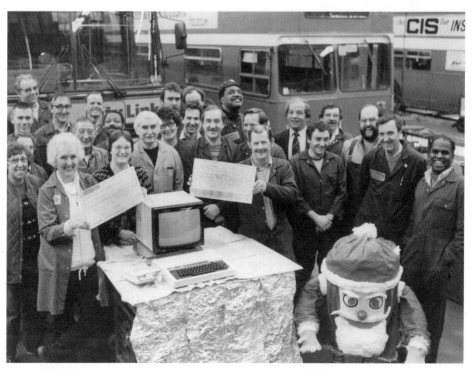

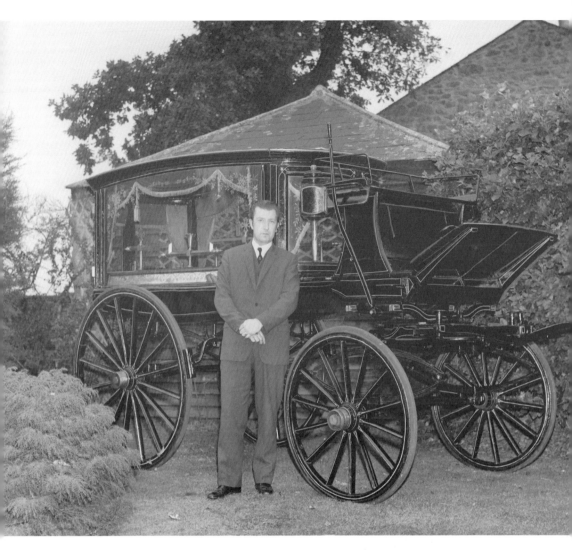

Funeral director Ronald Bromley stands in front of the last word in personal transport, a luxurious horse-drawn hearse which he managed to acquire in October 1970 after a long search. Having found this treasure, he was worried that he might not be able to find suitable horses to pull it but was assured that they could be obtained, complete with driver and plumes, at only two days notice.

4

IN THE COUNTRYSIDE

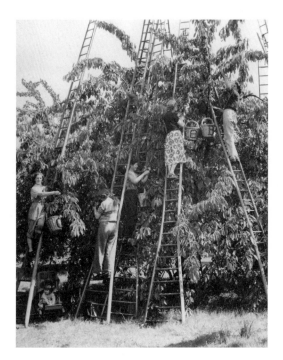

Cherry-growing at Harwell goes back at least to the seventeenth century, but it was in the period immediately after the Second World War that output was at its greatest. In the 1950s Gordon Bosley farmed 200 acres with more than 12,000 cherry trees yielding some 80-90 tons of fruit annually. He employed six permanent workers and more than 130 casual staff at harvest time. The cherries were sent countrywide and even exported by liner from Southampton. They were sold locally from a stall near the AERE site. This photograph, taken in 1954, shows pickers in the orchard shortly after it had won a Silver Medal from the Royal Agricultural Society as the best cherry orchard in the south of England.

A crop not normally associated with Oxfordshire is hops. Here they are being harvested from vines at the Southmoor hop-fields in September 1965. The vines are being fed into an automatic hop-stripping plant. They would have probably been used at one of the breweries in nearby Abingdon.

Opposite above: Students at Waterperry Horticultural School busy at work in the cucumber greenhouse in June 1961. Founded in 1932 as a residential horticultural college for women, for years the school had a shop in Oxford Covered Market where it sold all manner of produce, from vegetables to cut flowers and even Christmas puddings and mince pies in the approach to the festive season. Waterperry Gardens attracts a great number of visitors every year as well as hosting a whole range of courses in art and rural crafts.

Opposite below: Another famous local product is watercress, which has been grown at Ewelme for generations. The watercress beds were constructed in the 1890s by damming the chalk stream running through the village and at its peak the village sent its produce as far away as Covent Garden. After nearly a century, however, they went out of cultivation in 1988 due to legislation and competition from elsewhere. This photograph, which dates from the turn of the twentieth century, shows them in full production.

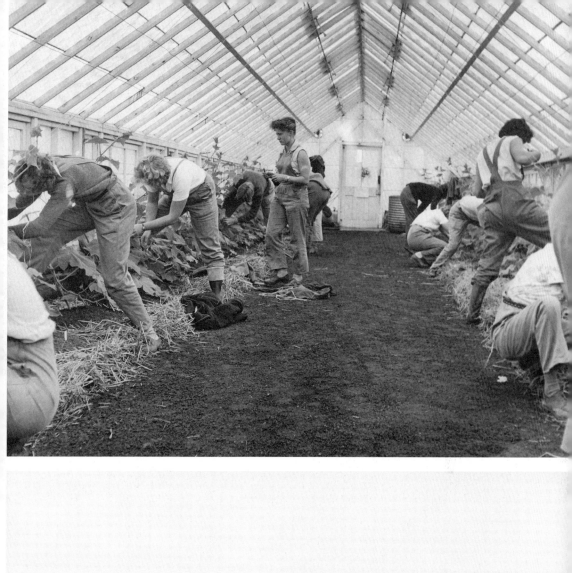

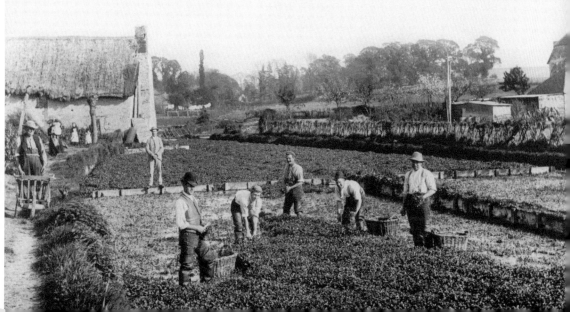

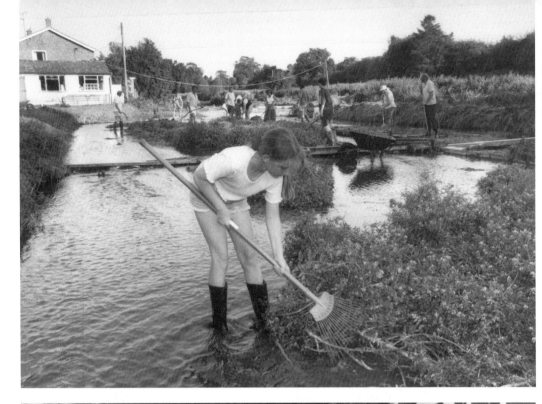

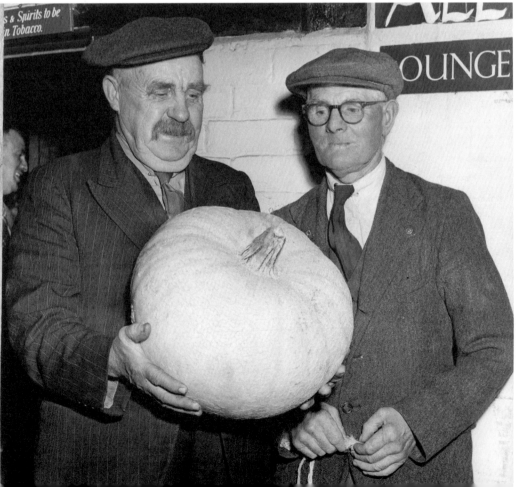

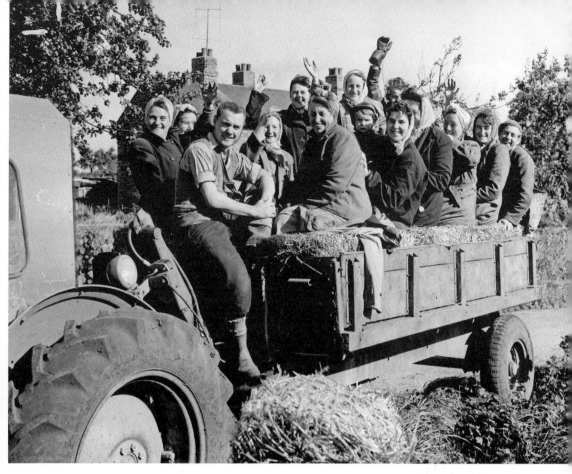

The ladies in this photograph, posing for a group picture in October 1958, were the last generation to go into the fields to pick potatoes by hand. This cartload came from Glympton and though the work was dirty and back-breaking, they seem very cheerful. No doubt they enjoyed the company and the chance to earn a little, and the farmers too were glad of the help.

Opposite above: After a period of decline, villagers at Ewelme tidied up the watercress beds and people adopted sections near their houses, which they cleared out and maintained. Volunteers became involved in the upkeep and maintenance of the site. In this photograph, taken in July 1995, 10-year-old Heather Chilcott is shown in action with her rake. In 2000 the site was bought by the Chiltern Society, which turned it into a nature reserve, and serious work began on the restoration of the watercress beds. The nearby wetlands now offer habitats for local wildlife and a new visitor centre was opened in 2004 by the Duke of Kent.

Opposite below: Several parts of Oxfordshire specialise in the growing of pumpkins, which are very evident at the end of October, around Halloween. Competitions are held to find the heaviest specimens and the village of Bampton even has its own Pumpkin Club, founded in 1969. In this photograph, taken in October 1958, William Jennings of Drayton St Leonard in south Oxfordshire tries to guess the weight of a pumpkin grown by Fred Richardson in a Harvest Festival competition at the Plough Inn, Clifton Hampden.

Four of Oxfordshire's farmers attending an open day at West Oxfordshire Technical College in Witney in April 1964 were A.J. Marks, H. Hobbs, J. Willmer and E.J. Turner. They are shown taking time off from hearing about up-to-the-minute agricultural practices to examine this old machine, which was used to grind mangolds.

In September 1969, ploughs were one of the main topics of study for students at the Department of Agriculture, West Oxfordshire Technical College. The lecturer gave practical instruction on this tractor-drawn model and also demonstrated just how it worked. It would have been sensible for him to also point out that lighted cigarettes are not good practice in the vicinity of petrol.

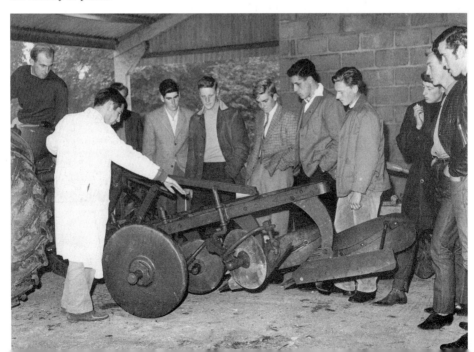

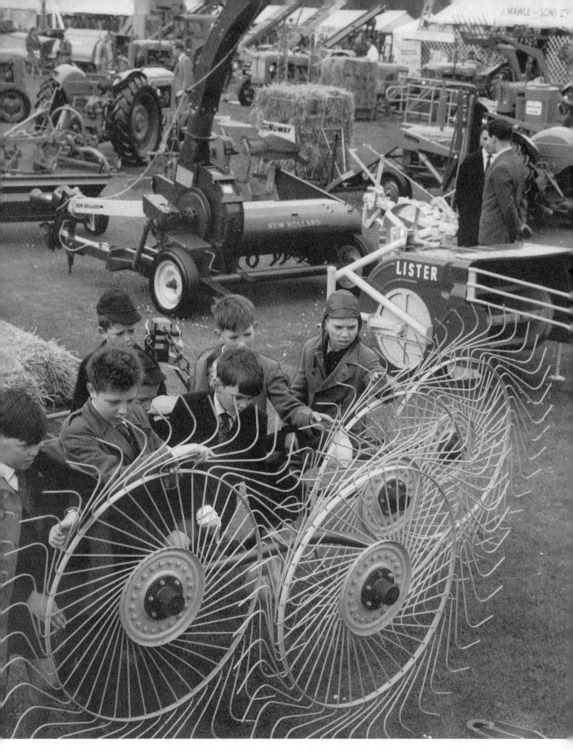

This group of boys from Freeland School seem entranced by a hay-turning machine. They were visitors to the 151st Oxfordshire Show at Kidlington, which was held in May 1962. By 2.30 p.m., the attendance figures had reached 4,949, a thousand more than the previous year. The show has since combined with Thame Show to become the Oxfordshire County and Thame Show and is held at Thame.

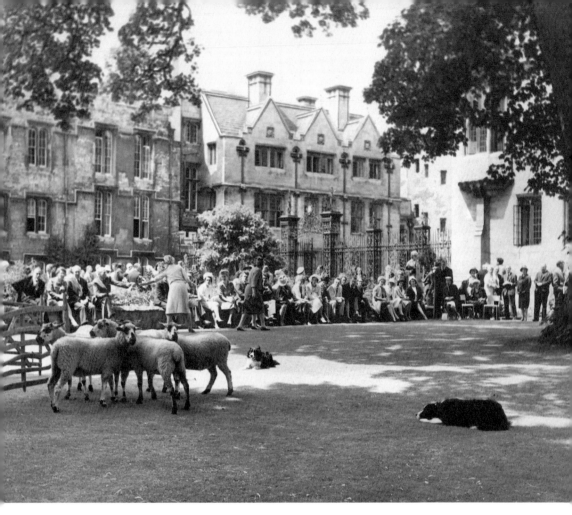

As part of the college's 700th anniversary celebrations in July 1964, college tenant farmers and their wives were entertained at Merton. Among the attractions was a demonstration by two dogs and five sheep belonging to Christopher Winterton of Merton Farm, Barkby, Leicestershire. The 200 guests watched the half-hour demonstration in the college gardens. The older colleges were endowed with manors, farms and land all over England, which is why it is not unusual to find college farms and public houses bearing their arms throughout the country.

Opposite above: Sheep-shearers demonstrate their skill to an admiring audience at the Oxfordshire County Show in May 1964. Groups of expert shearers, some from as far away as Australia and New Zealand, would tour sheep farms undertaking casual work during the early summer months. For centuries one of the county's main products was wool and its associated products, as is shown by the fine 'wool' churches extended and decorated by wealthy merchants in towns such as Witney and Burford.

Opposite below: Super-cow Mackney Spot 7th, who had recently achieved a total of 100 tons of pintas, poses in May 1988 with the trophies won by the Mackney Herd of Friesians of Brightwell-cum-Sotwell, near Wallingford. With the mother of eleven are milk-tanker driver Edward Clark, owners Michael and Angus Dart, farm manager Derek Loosemore and herdsmen John Wooliscroft and John Chappell.

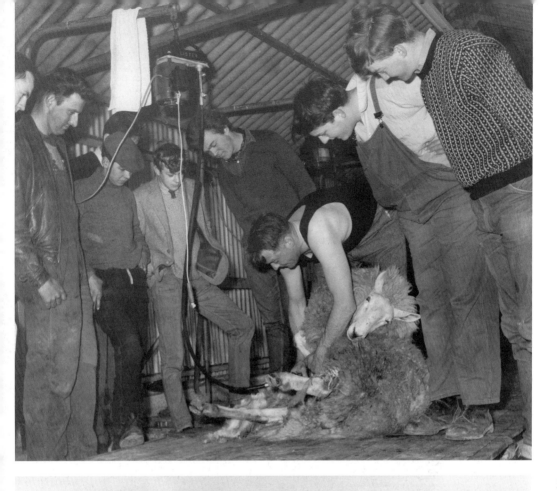

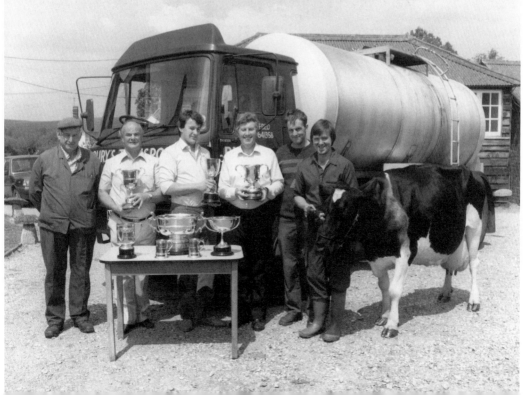

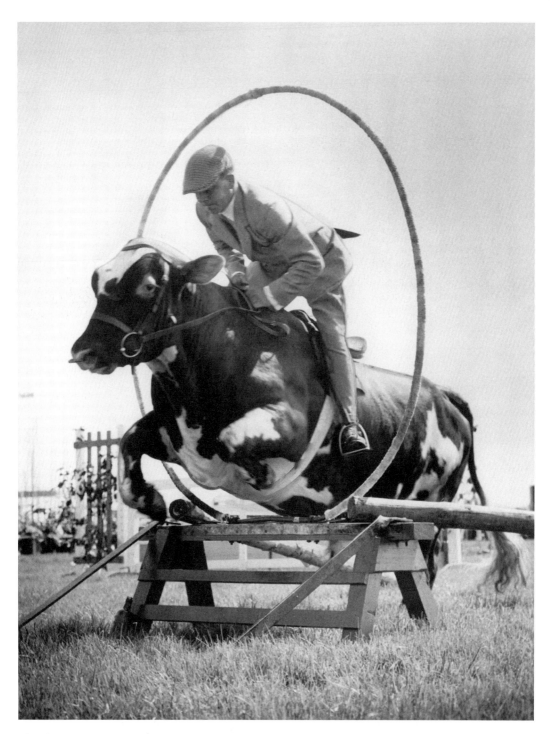

The ultimate in showmanship is this demonstration of show jumping, given by Colin Newlove at the Oxfordshire County Show in 1964. From the resigned look on his face, William the Ayrshire bull was somewhat less enthusiastic than his owner. By no means are all bulls this amenable and it was not unknown for stock handlers to suffer serious injury and occasionally even be killed by their charges.

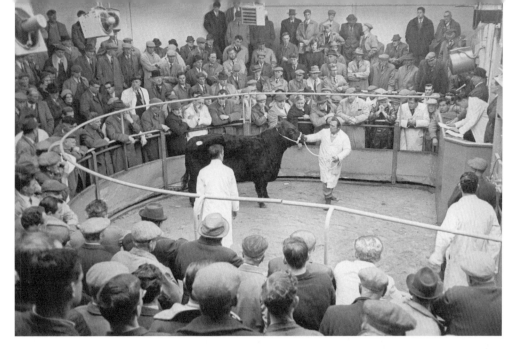

A view of one of the sale rings at Midland Marts Ltd's Banbury livestock market in January 1958, when it was a 'super market for the supermarkets', as its chairman managing director put it. With up-to-the-minute facilities and the fastest auctioneers in the country, the Banbury market grew into the largest in Europe. However, in June 1998 it was forced to close for a variety of reasons, not least of which was the outbreak of BSE, which drastically reduced the consumption of British beef.

The Downland region, which stretches from the west of the county into neighbouring Berkshire, is internationally renowned for its racing stables. Generations of winners of the racing world's most prestigious prizes have been bred or trained in this area. This string of racehorses — all trained by Ken Cundell of Compton — was photographed on their way to a gallop on the Berkshire Downs in May 1967.

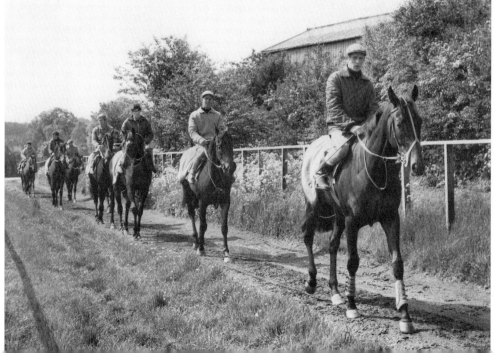

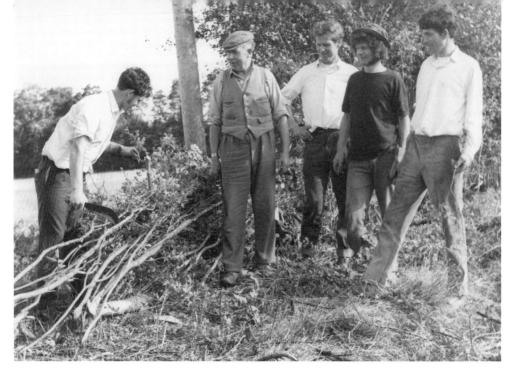

One family became so expert in the skills of hedge-cutting that no less than eight of them were involved. In this photograph Denis Paget is showing why he won the silver cup at the Fairford, Faringdon, Filkins and Burford Ploughing Society's match at Buckland in 1970. Looking on are his father, Bert, and brothers Ernest, Ken and Ronnie. The brothers won 1st, 2nd and 3rd prizes at the contest.

At Wick Farm, Headington, just outside Oxford, in February 1974 the speciality was beef cattle. Members of Drayton Farming Club are shown being taken on a tour of the farm by the farmer, Mr J.R. Buswell. Today the Buswell family operates both Wick and Bayswater Farms as mobile home parks, situated close to both the amenities of Headington and the open countryside.

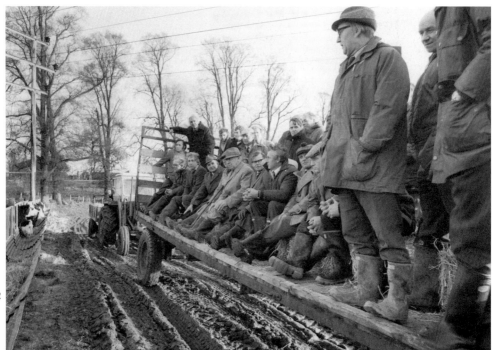

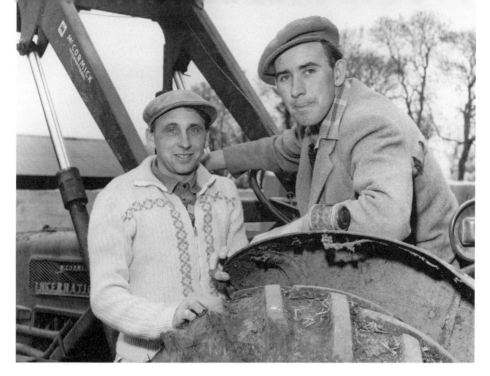

At the 1962 Oxfordshire Show were two long-serving employees; Mr J. Smith (left) and Mr A.F.W. Harris of Aston. Although these two look too young to be singled out for their length of service, they would have been able to leave school and start working when they were about 14. A distinct deterrent to switching employers at this period was the fact that many farm workers lived in tied cottages.

At the Oxfordshire Show in May 1961, this trio of Bronze Age farmers was spotted taking a well-earned lunch break with a picnic on the bales of straw. Taking part in a pageant which represented farmers through the ages were J. Cordrey and Miss D. Keayes, who are waiting for Miss A. Rowles to be the first to try out a roasted leg.

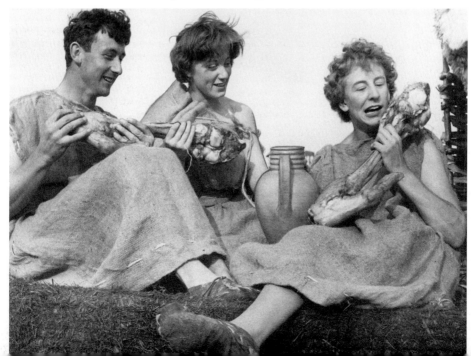

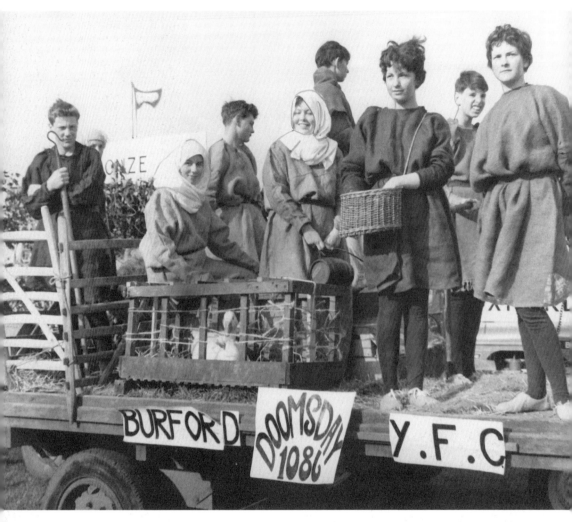

Moving on more than a thousand years, this float shows how Burford Young Farmers imagined their predecessors would have appeared at the time that the Domesday survey was taken in 1086. The various aspects of medieval farming were included and the duck in the crate appears to be enjoying the outing.

Beekeeper Anthony Rowse managed to turn a hobby into a successful business. Starting off in Ewelme, he later moved to Wallingford. The Rowse Honey Co. came into being in 1954. Anthony is shown here in January 1969 trying to work out the most efficient way to fill jars with honey. At that date many tons of honey were already being processed every week and today the company produces about 34 per cent of the UK's honey and employs more than 100 people.

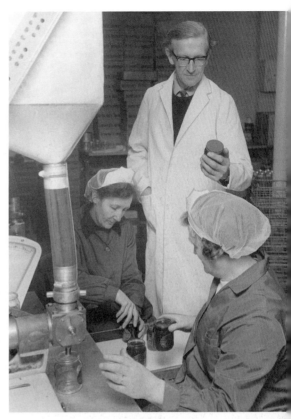

In July 1980, as part of Cogges Museum's series of demonstrations of rural crafts, Bob Penrice of Farm Mill Lane showed visitors how to extract honey from a honeycomb. Having smoked off the bees, Mr Penrice took the combs into the museum's Edwardian kitchen, where he used a cylindrical spinner to rotate them so that the honey flowed out and straight into jars. He also demonstrated how to make wax candles.

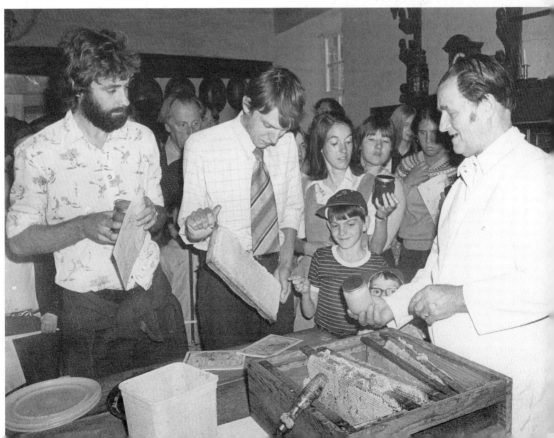

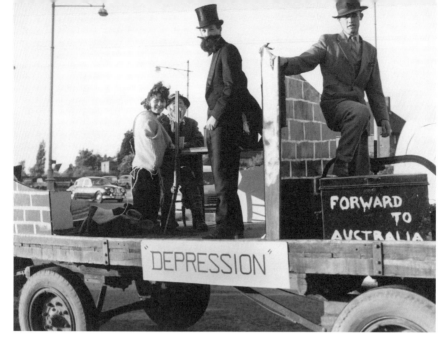

A float in the Youth Farmers' pageant, 1961. They represented the farming community in late-Victorian times when agriculture was going through a very bad period. Many people left the land and emigrated in search of better lives. Although these young farmers are bound for Australia, Oxfordshire and Cornwall were the main English counties to see agricultural workers leave for a new life in New Zealand.

Rural poverty, although always relative, is never very far from the minds of country people. Agricultural workers are traditionally among the lowest paid in Britain and protests erupt from time to time. This photograph, taken in November 1977, shows a march through the streets of Abingdon organised by members of the Berkshire and Oxfordshire branch of the Agricultural and Allied Workers Union in support of a £60-a-week pay claim.

5

SHOPS AND BUSINESSES

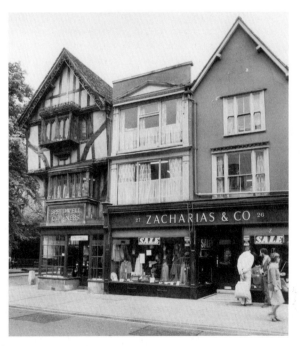

Zacharias & Co. in Cornmarket, Oxford, shown here before it closed in 1983, was famous locally for the slogan 'Zac's for Macs', even though it sold a complete range of menswear. The name came from Joel Zacharias, who traded from the premises in the second half of the nineteenth century and considerably altered the appearance of the buildings on the site. The restoration, which was completed in 1987, cost the owners Jesus College around £500,000, and employed timber experts Alfred Groves & Son Ltd of Milton-under-Wychwood. Looking very much as it would have done in the time of Richard II, the building reopened with Laura Ashley as the new shop tenants and student accommodation above.

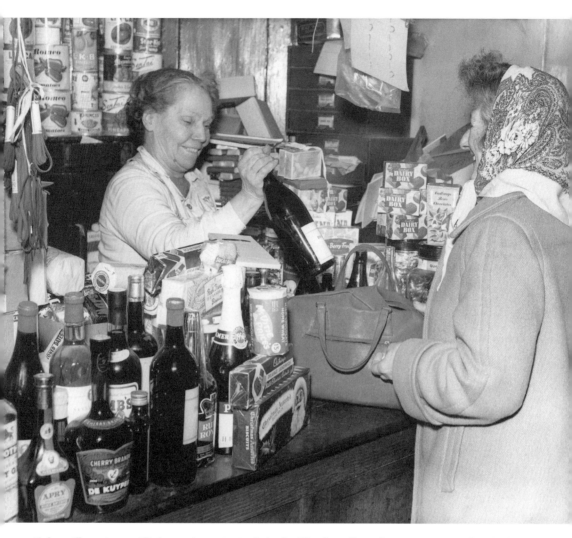

Today, village stores still play an important role in the life of small rural communities and in 1959, when this shop at Waterperry was photographed, this was even more the case. Miss Sarah Biggs had been sub-postmistress and proprietor of the general store for thirty-eight years.

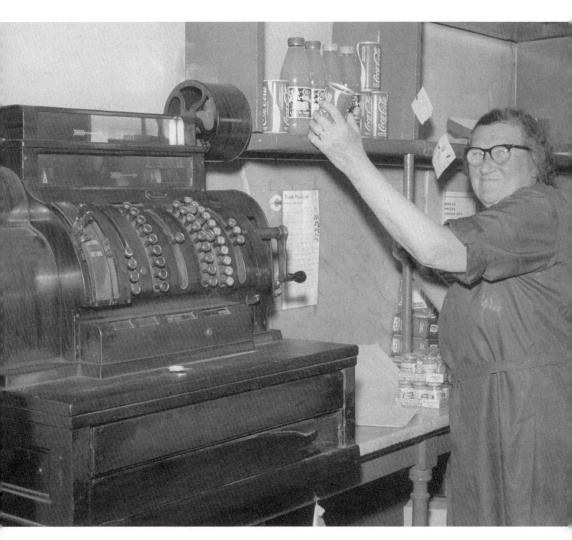

Mrs Lucy Hudson of Mill Street Stores is shown here in September 1979, shortly before she put the shop up for sale after forty-three years. With her is the ancient National Cash Register till, which had been there longer than she had. It was made in America in the 1890s, and was for sale as part of the shop fittings. Mrs Hudson had already been offered £600 for the till, which was in perfect working order, although it only dealt in pounds, shillings and pence.

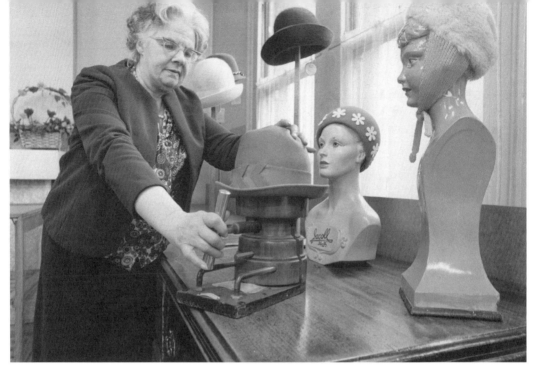

In its heyday, family business F. Cape & Co. had branches in Headington, Walton Street and Cowley Road. In the millinery department in December 1971, shortly before the shop's last Christmas, employee Miss C. Winfield – seen here surrounded by some very serviceable winter headgear and rather battered models – is using a hat-stretcher.

The scene inside Cape's when it closed in 1972 after 105 years in St Ebbes Street. Its fifty members of staff were made redundant and the furniture, fittings and remnants were sold by auction at the end of January. The reason given for its closure was that the building had 'almost worn out' and that up-to-date shops were by then self-service.

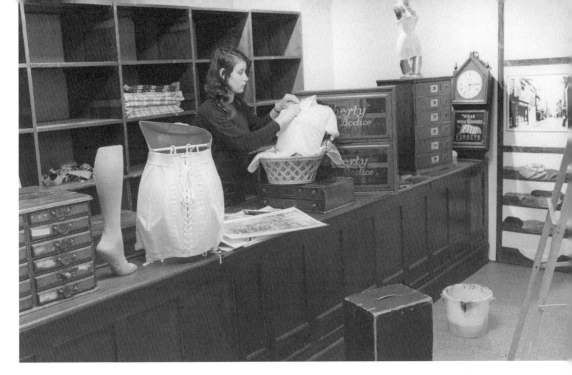

Cape's, which was founded in 1867 in St Ebbes by Faithful Cape, was sold thirty years later to Henry Lewis, whose grandson was chairman when the shop closed. When the store was demolished and a three-storey building put up in its place, part of the interior was taken off to the Oxfordshire County Museum where an exhibition was constructed. Here is the rebuilt corsetry counter in May 1975.

Another well-known and long-established department store was Ward's of Oxford Ltd, which specialised in furniture and furnishings. The business was founded soon after the First World War by Mr and Mrs Thomas Ward in their front room in Park End Street. When it expanded, another shop was opened in Cowley Centre in 1962. When this picture was taken in May 1972, Ward's had nearly sixty employees. However, the future was uncertain and there was talk of mergers as well as a move to the new Westgate Centre, which never materialised.

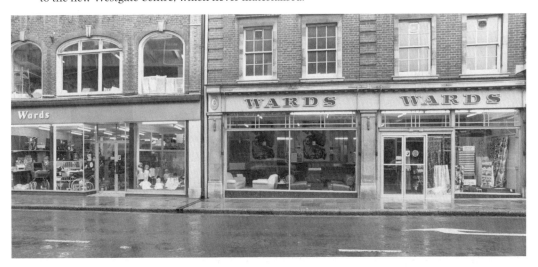

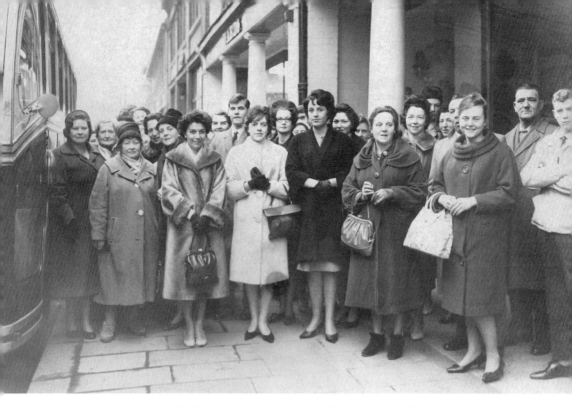

These are just a few of the 400 Ward's employees and their friends who set off for a works outing to the British Furniture Manufacturers' exhibition at Earls Court in February 1962. The previous week 200 people had already been to see the exhibition. Although this was Ward's staff's first visit, it was hoped that it would become an annual event.

Opposite above: The January and July sales were eagerly awaited events, with crowds queuing outside for hours to be the first inside to get the pick of the bargains. As this picture, taken at Ward's in January 1960, shows, not all the items reduced for sale were glamorous, although the prices compare very favourably with today.

Opposite below: A bride of the year competition, sponsored by Ward's of Oxford, was won by Olive and Barrie Goddard in April 1968. After selecting the correct order for fourteen slogans, Mr and Mrs Goddard were presented with a suite of furniture worth £100 by Mrs F. Cooper, chairman of Ward's, who made the presentation in the Southern Gas Board showroom in St Aldates.

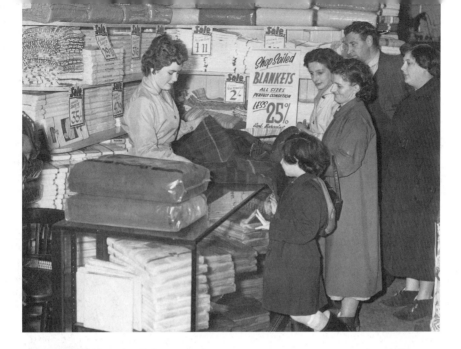

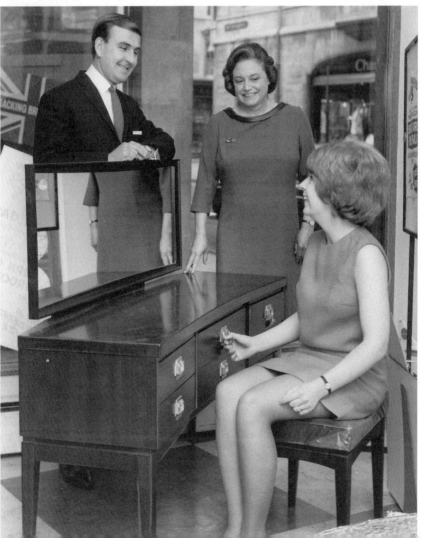

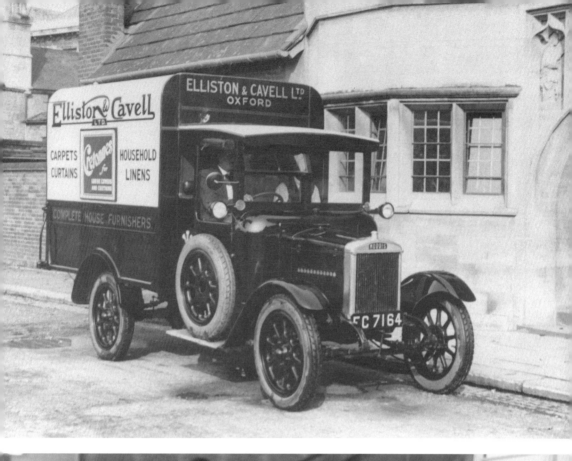

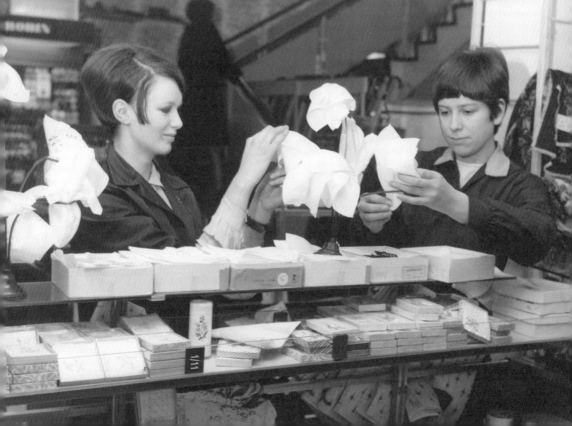

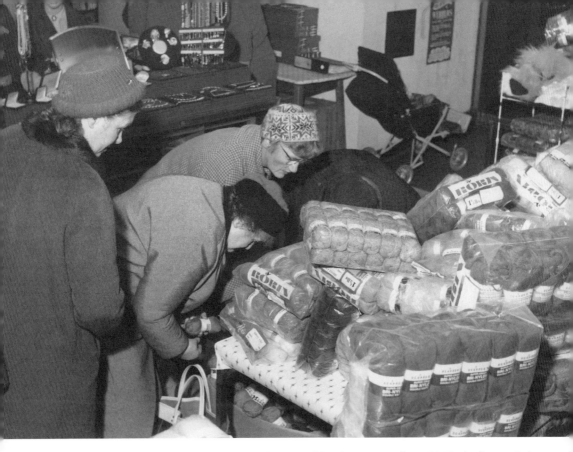

Bargain hunters sort through the wool on offer at Webbers' January sale in 1968. At that period hand-knitting was still very common, although, as the photograph shows, synthetic fibres were readily available. The most central of Oxford's department stores, Webbers was also its largest, with no less than thirteen bays on the High Street, stretching across Avenues 1, 2 and 3 of the Covered Market. In 1952 the business was bought by Hide & Co. and in 1971 it closed.

Opposite above: Jesse Elliston was the owner of a draper's shop opposite Oxford's St Mary Magdalen Church. In 1835 John Cavell became a partner in the business, which became Elliston & Cavell and eventually the city's largest department store. It kept the name until 1973, despite having been taken over by Debenhams twenty years earlier. This Morris delivery van, parked in Gloucester Green in 1924, is outside the old Central Boys' School, later the bus company booking office.

Opposite below: Sales assistants Sarah Fathers and Christine Tucker get ready for the 1968 January sales at Webbers. The site had a long association with the drapery business. The 1851 Census shows that in that year No. 12 High Street, Oxford, was occupied by draper Samuel Evans, his wife and two children. Above the family's quarters lived Samuel's eight assistants and two servants. By 1905, when they were bought by Charles Webber, Nos 10-12 had become the City Drapery Stores and not long afterwards Webber bought up the shops on either side.

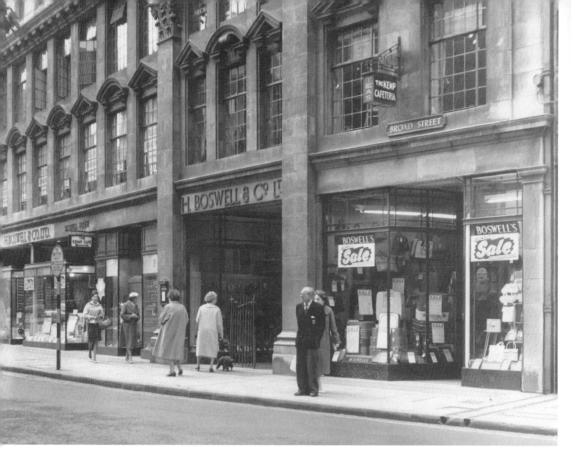

The Broad Street frontage of H. Boswell & Co. Ltd is pictured in October 1962, before its modernisation and the removal of the arcade. Boswells has been in business since 1738 and is now the largest independent department store in Oxford. It started when Francis Boswell sold travel goods at No. 50 Cornmarket, and the family involvement lasted until 1890, after which it was bought by Arthur Pearson of the Oxford Drug Company, although the original shop survived until 1928. The following year they moved to the present site, Boswell House, on the corner of Broad Street and Cornmarket, which still incorporates the Oxford Drug Company and both businesses remain in the hands of the Pearson family.

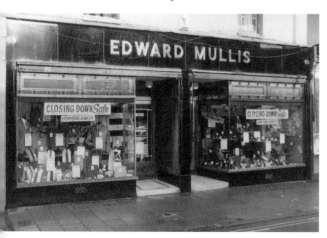

Edward Mullis, the gentlemen's outfitters in St Clements, was already something of a relic and on borrowed time when it finally closed its doors in December 1985. It was one of those small businesses which were very common in English towns in the post-war years but were rapidly replaced with the coming of teenage fashions in the early 1960s.

Proving that traditional menswear is not reliant on the current fashion, the clothes on display in Hall Bros in Oxford High Street, pictured here in June 1991, have changed very little over the decades. The sign in the window, 'William Northam, University Robe Makers,' reveals its origins as one of many such businesses which flourished in the nineteenth and early twentieth centuries. Hall Bros, once notable for its Prince of Wales feathers symbol which signified royal patronage, has been taken over by royal tailors and robe makers Ede & Ravenscroft, themselves founded in 1689.

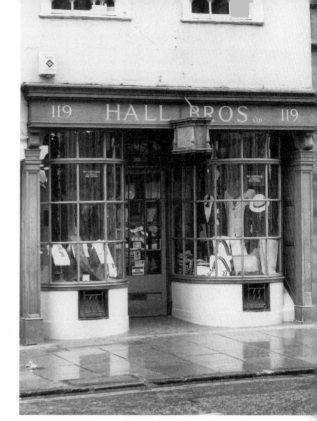

These people are queuing outside Walters, the top men's shop in the Turl, Oxford, in January 1981, for bargains in the January sales. Within an hour of opening the shop had to close again, as the staff could not cope with the stampede, leaving a long queue outside. Customers, including the Lord Mayor Gordon Woodward, were lining up twenty deep to pay at the tills and Leslie Ody, Walters' managing director, said he had never seen anything like it before.

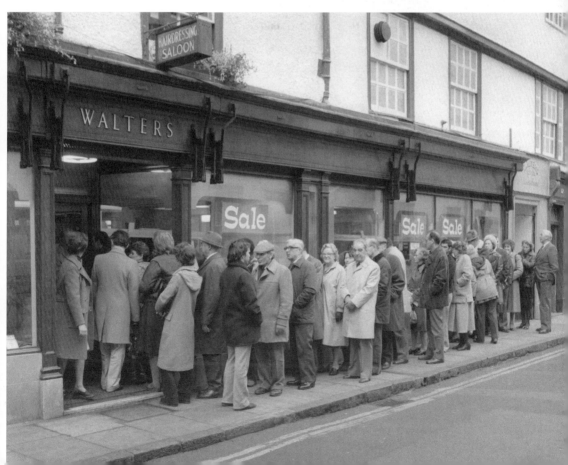

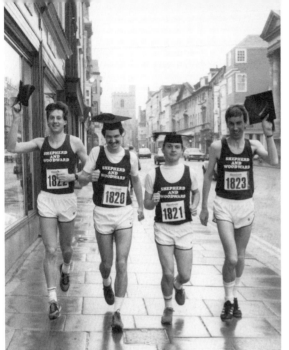

Practising for the Abingdon Marathon in April 1986 are Team Shepherd and Woodward, from left to right, Adrian Palfreyman, Nicholas Bedding, Nicholas Penfold and John Hicks. In 1877 Arthur Shepherd opened his first outfitters business in Oxford at No. 62 Cornmarket. After moving to No. 6 Cornmarket, he demolished this building and No. 8 in order to make one large new shop. In 1929 Shepherd joined forces with Wilton Woodward, whose shop was at No. 110 High Street, and they expanded their joint business first into the adjacent corner shop and later added No. 13 High Street. The Venables family became involved in 1927 when Arthur Shepherd took on Dennis Venables as an apprentice. The outfitters and academic dress business is still in the family, the present managing director, Adrian Palfreyman, being married to Dennis's granddaughter, Tracie. Shepherd and Woodward now trade from five locations in Oxford.

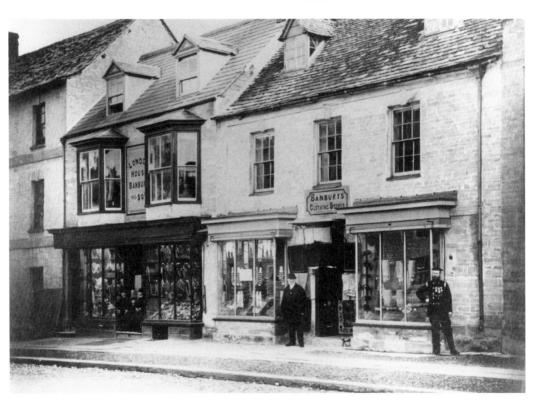

This old photograph of Banbury's Clothing Stores in Woodstock was taken in the 1880s. Posing outside are Gabriel Banbury (on the left) and his son John, dressed in the uniform of a captain in the Volunteer Fire Brigade. Gabriel's great-grandson, Charles, continued the business as men's outfitters.

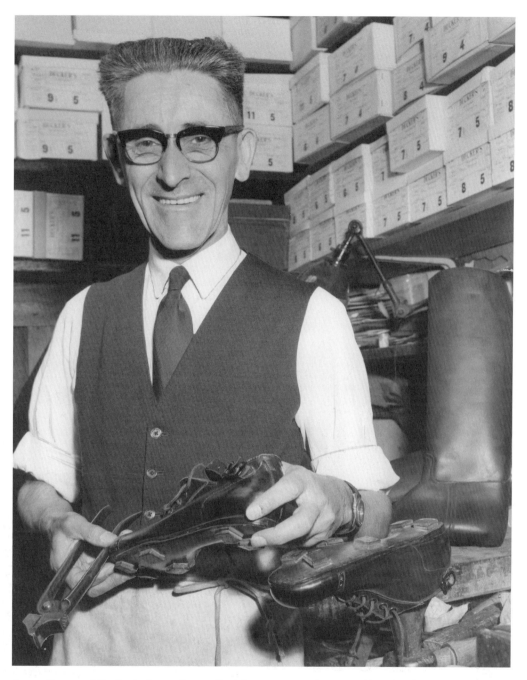

George Purves of Ducker's shoemakers in Turl Street poses with a pair of beagling boots in June 1968. Duckers is one of the longest-established of Oxford's companies, having been founded by Edward Ducker in 1898. At that date he was just one of more than a score of boot and shoemakers in Oxford. When he died in 1947, Edward left the business to his wife, only for her to die a fortnight later. The directors and shareholders of today's Ducker's include some of Edward Ducker's descendants. Now the business is one of a few hand-sewn shoemakers in the provinces and its ledgers contain the names of J.R.R. Tolkien, Evelyn Waugh, Sir Matthew Pinsent, Rowan Atkinson and Jeremy Clarkson.

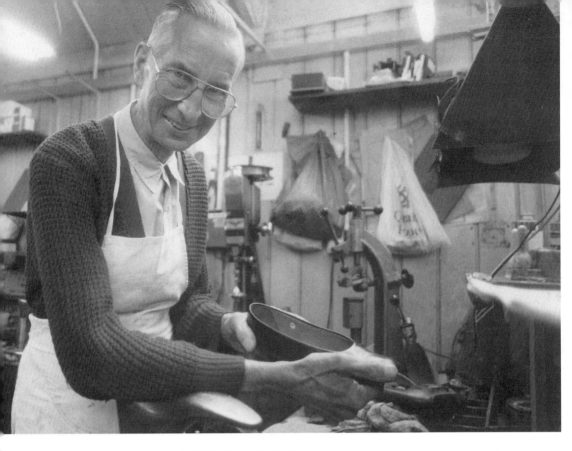

Roy Smith is pictured here in September 1996 celebrating fifty years as a shoe repairer at Bailey's shoe shop and repairs business in Bath Street, Abingdon. The shoe repair side of Bailey's is still in business in Abingdon at No. 12a Bath Street.

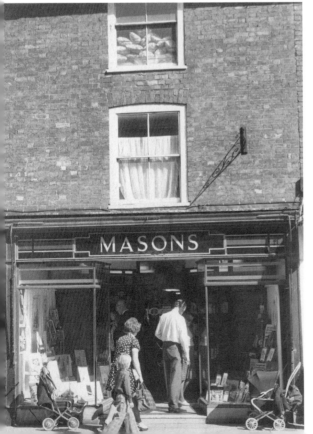

Masons needlecraft business was bought by the North family in 1939 and has been owned by them ever since. It has expanded from a shop which sold hosiery, children's clothing and knitting wool to occupy three premises in Abingdon, two adjoining shops in Bath Street and this listed building in Stert Street, formerly the Mitre, shown here in September 1975. Today, Masons' shops are crammed full of sewing, knitting, needlework and craft items.

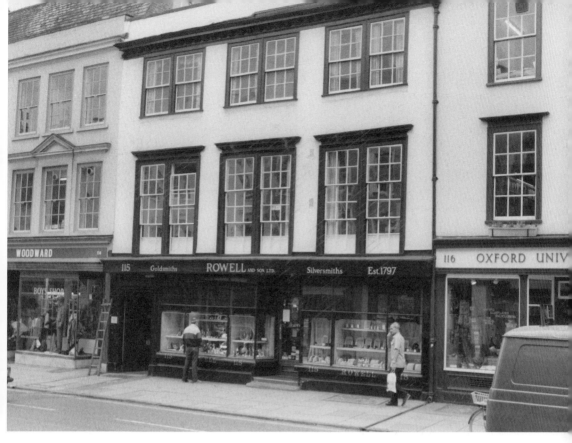

Opened in 1797, Rowell of Oxford is one of the city's longest-established jewellers. Situated in Turl Street, the shop has been a favourite with both Town and Gown, making as well as selling jewellery and bijouterie. Today Rowell's retains its Victorian display cabinets, which contain an eye-catching array of jewellery and clocks.

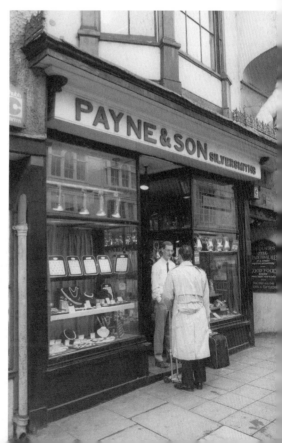

At No. 131 High Street, not far from Carfax, is Oxford's other historic jewellers, Payne & Son, which dates back to 1790 when John Payne opened a jewellers and silversmiths in Wallingford. Other shops followed in Abingdon, Banbury and Tunbridge Wells, all run by members of the Payne family. George Septimus Payne moved the Abingdon business to Oxford in 1888 and trading started as Payne & Son (Goldsmiths), Oxford. Today the seventh generation of the family is still in the business.

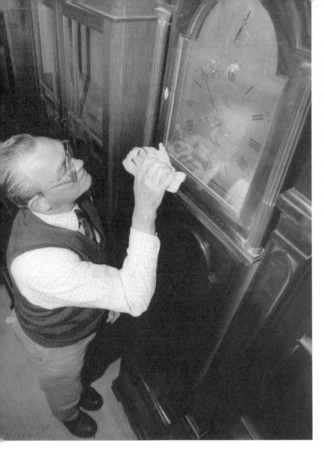

This is the sale room of auction house Simmons & Sons of Watlington, where, in April 1995, Charles Cassell was busy polishing an 8ft-tall long-case clock, made locally in Wallingford by Robert Keate in 1790. With easy access to visitor highlights in the Thames Valley and the Cotswolds, Oxfordshire is ideally placed for the antiques trade and until quite recently virtually every town had at least one antique shop. Antiques and collectables are still very popular – as the number of television programmes which include visits to auction houses proves.

Although the sign above Ledger's doorway advertised for antiques, what they in fact sold could be more accurately classed as bric-a-brac. The collection of reproduction warming pans and horse brasses is in marked contrast to the sportswear in the right-hand window. The poster in the window announces that the business was founded in 1918 and when this picture was taken of the St Aldates shop in August 1984, it was very elegant compared with one outlet that they had just bought near Folly Bridge, which was more like a portacabin than an antique dealers.

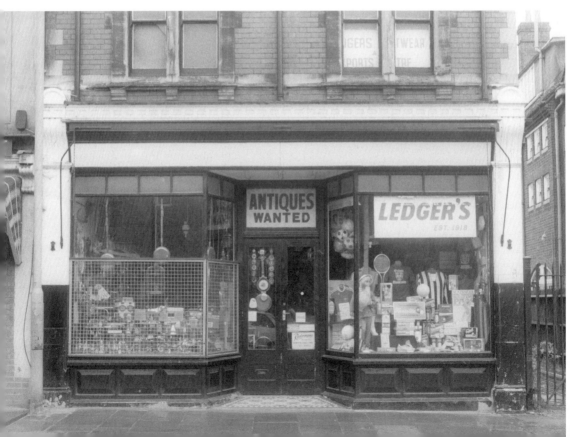

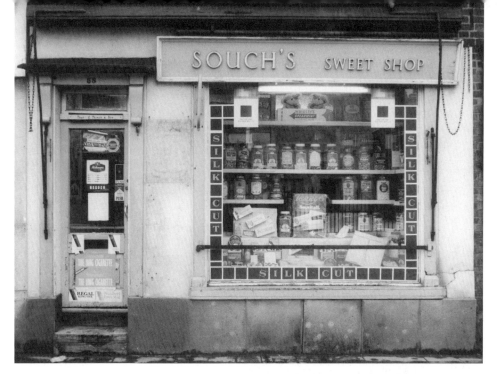

Souch's sweet shop in St Clement, Oxford, used to be a Mecca for local children for generations and is still fondly remembered by some. Customers entering the shop often thought they had stepped back in time. When Souch's closed after 150 years to become a hairdressing salon in January 1985, the owner said that the place hadn't been touched since 1956.

M.D. and D.F. Streeter's 'High Class Family Butcher' was a leading business in the village of Chinnor when this photograph was taken in March 1962. At that time the shop was over a century old and claimed that Prince Albert was once the landlord.

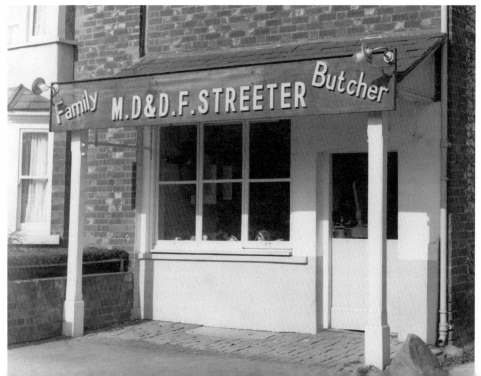

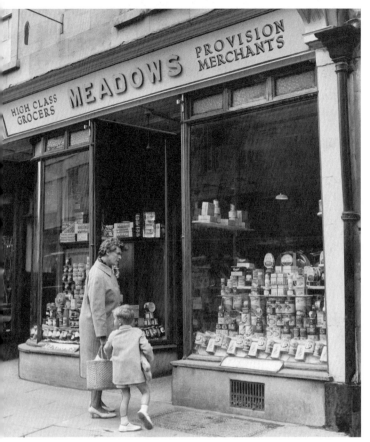

In August 1963 another long-established grocery business closed. This was B.G. Meadows Ltd in Market Street, whose business was transferred to Twinings and the staff transferred to other branches. Meadows' shop, an Oxford Corporation property, had been acquired by Twinings on the death of the son of the founder.

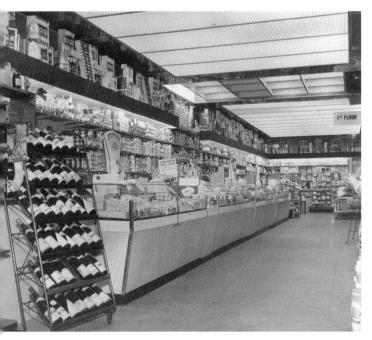

The interior of Grimbly Hughes' Queen Street grocery shop in November 1961. In 1840 Owen Grimbly and James Hughes opened a shop at No. 56 Cornmarket Street, Oxford, but in 1857 the shop was damaged by fire. Another fire which broke out in 1863 burnt the shop and its neighbour to the ground; they were rebuilt the following year into an imposing five-storey edifice, which became a local landmark. In August 1959 it was sold to Littlewoods and later demolished and replaced by their new store. Grimbly Hughes moved to No. 35 Queen Street in 1961, only to close for good two years later.

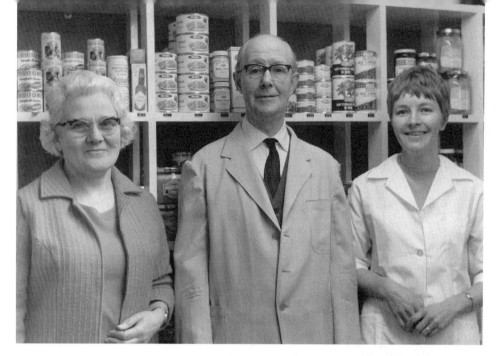

The oldest wine firm in Oxford, G.T. Jones & Co., opened in 1787. In 1959 it was acquired by the Tolly-Cobbold Brewery Group which took over the lease of the King's Arms in Holywell in 1962. Pictured here in February 1968 on the opening of the new delicatessen department are the manager and his wife, Mr and Mrs E.A. Stand, and Mrs June Heredge, who was in charge of the delicatessen.

These Banbury shop assistants are busy enrolling on a retail distribution course at the North Oxfordshire Technical College and School of Art. In January 1968 more than forty students started the training course, which aimed to improve the quality of service the public received in both supermarkets and village stores.

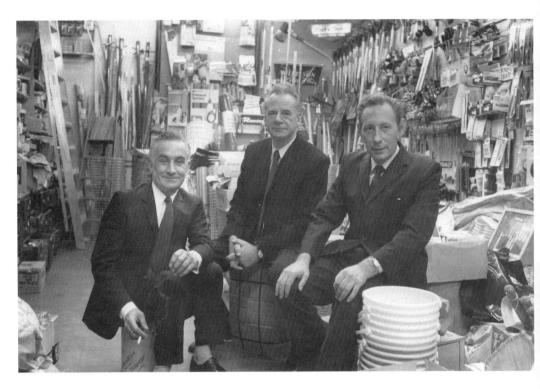

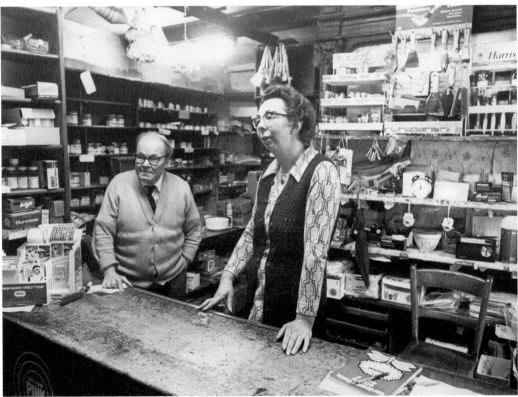

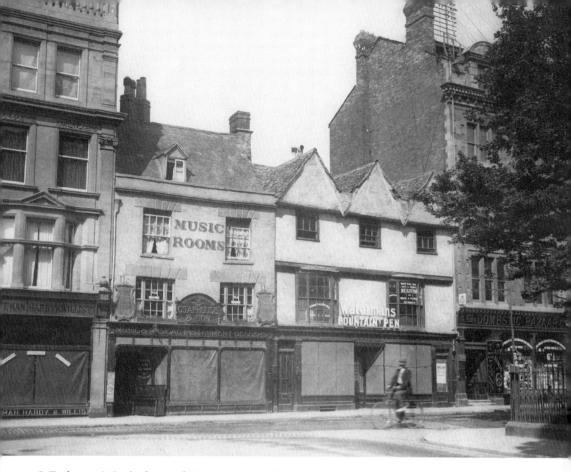

C. Taphouse & Son's shop and Music Room at No. 3 Magdalen Street, Oxford, at the beginning of the twentieth century. In the early 1840s, Charles Taphouse, a cabinet maker from Hampshire, came to Oxford and after opening and closing several shops, settled in Magdalen Street in the former Woodstock Arms where he sold pianos, organs and sheet music. The shop went from strength to strength and in the 1960s Taphouse's, along with Russell Acott's, was a meeting place for local teenagers who would listen to the latest hits in the soundproof booths. When that part of Magdalen Street was redeveloped with the expansion of Debenhams, Taphouse's relocated to the Westgate Centre in 1982 before closing for good shortly afterwards.

Opposite above: Members of staff at Gill's Ironmongers pose for a photograph in September 1973. The shop is tucked away in Wheatsheaf Yard, which runs between the High Street and Blue Boar Street in Oxford. This is one of the country's oldest ironmongers with a history which goes back to the middle of the sixteenth century under a variety of names. Its present one comes from James Gill who, in about 1840, went into business with ironmonger James Pilcher at No. 5 High Street. The business had five different homes in the High Street before moving to the present location in the early 1950s.

Opposite below: Part of the Woodstock shop owned by Mrs Dunkley and her brother Herman Brotherton used to be in Mrs Dunkley's sitting room. It sold just about everything, as long as you could find it! In February 1977, the Dunkley family still owned the shop, which had once been three front rooms. The carved panelling in Mr Dunkley's office had once graced nearby Blenheim Palace. Bob Dunkley is shown with the morning worker, his niece Mrs Wendy Howse, while his daughter Mrs Sheila Pratley worked in the shop in the afternoon.

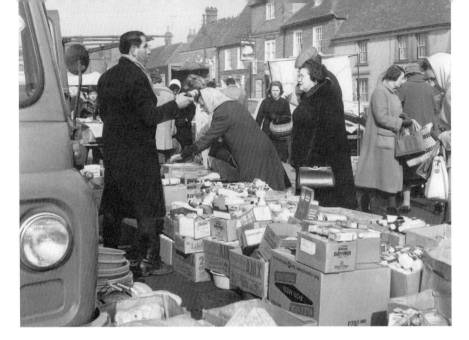

English markets date back to the Middle Ages and the Tuesday market at Thame, shown here in March 1963, received its Charter in 1215. Today it is joined once a month by a Farmers' Market, and occasionally there is a French Market. Thame's Upper High Street claims to be the widest street in the country (about 190ft-wide at one point). The size of the market place is the result of a bishop of Lincoln having diverted the old road to Aylesbury so that it could not be avoided.

Oxford's Covered Market was opened in 1774 to clear the city streets of clutter and rubbish from the stalls. At first largely full of butchers and other food traders, it is now an Aladdin's cave of exotic merchandise and a variety of places to eat. This photograph shows the market as it was in December 1961, when the goods for sale were much more like those to be found in a traditional outdoor market.

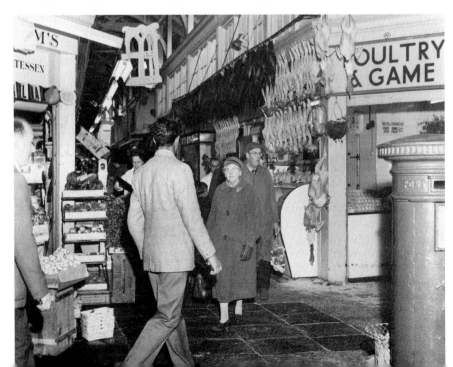

6

MANUFACTURING

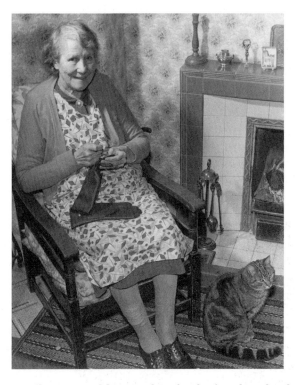

Mrs R.M. Bowden, pictured here working by the fireside in her home in Long Hanborough in January 1959, was one of the last generation of out-workers to be making gloves in north-west Oxfordshire, an industry which had been carried on in and around Woodstock for over four centuries. Mrs Bowden had been making gloves by hand for more than sixty years and reckoned to put approximately 1,110 stitches into every pair that she made.

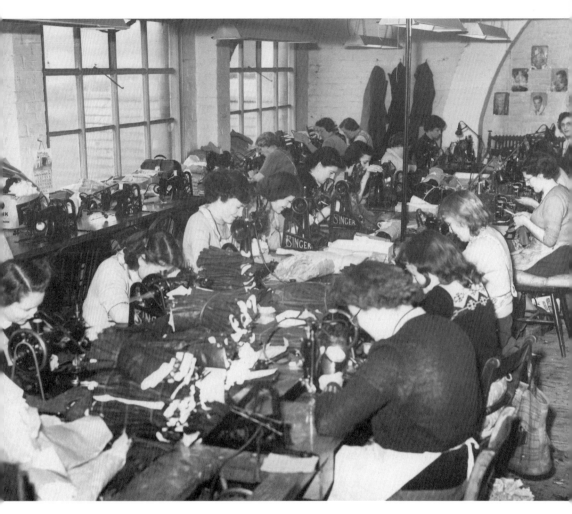

In 1889, Pullman's, a London company, built a factory at Hensington. This was originally called the Woodstock Glove Co. but became known as R. & J. Pullman's from the early twentieth century. This view of the shop floor at R. & J. Pullman Ltd of Woodstock dates from about 1960. By this date the glove-making industry had begun to decline, the reason given by manager Stanley Thorne being that it was no longer the fashion for professional men to carry gloves when they went out. Another reason was the fact that local women preferred to work in the new, modern factories rather than at home or in small old-fashioned premises. Pullman's closed in 1966.

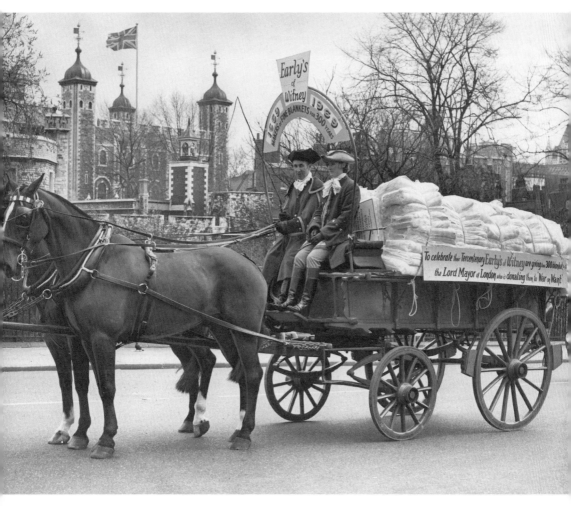

One of Oxfordshire's oldest and most famous industries was the manufacture of blankets at Witney, where several mills were a feature of the town. In April 1969, Charles Early and Marriott (Witney) Ltd celebrated the firm's 300th birthday by sending this wagonload of 300 blankets to the Mansion House in London for the Lord Mayor to distribute to needy communities all over the world.

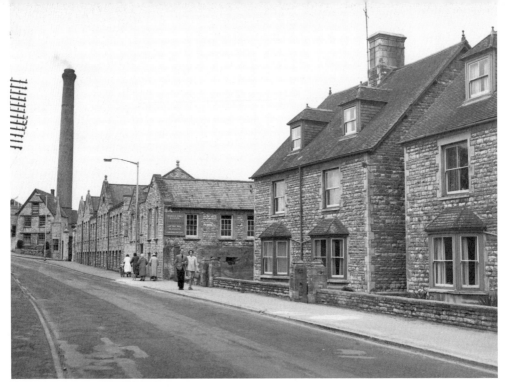

Hundreds of Witney people were employed in the blanket industry and several housing developments in the town were built to house mill workers. This photograph, taken in Mill Street in October 1958, shows the last mill to survive, the Witney Mill, then trading as Charles Early & Co. Ltd, which closed in 2002. The whole mill complex has recently been converted into housing.

West End Post Office and Stores, photographed in February 1991, was once an alehouse known as the Jolly Tucker. Until the nineteenth century, tuckers carried out the finishing-off processes. This was one of the places where the Witney Tuckers' Feast was held and the men were paid for their work over the previous six months. Both the post office and the adjoining Fish Bar have since gone.

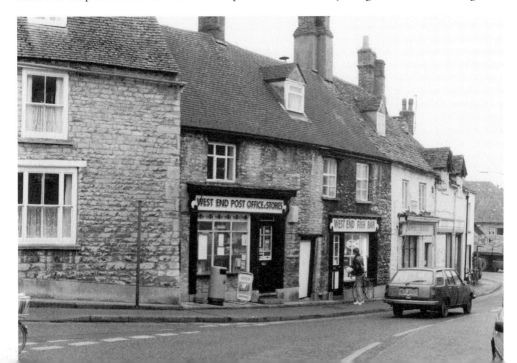

This aerial photograph of the Windrush Valley housing development, built by Taylor Woodrow at Witney, was taken in October 1982 to illustrate a report on the shortage of housing in the Witney area. The report also marked the construction of the 1,000th home for the employees of Smith's Industries in 1961. In September 2006 the works' closure was announced with a loss of thirty-six jobs. Sifan closed its site on the Windrush Industrial Park later that year and production was switched to its sister company, Torin, in Swindon. Some of those who lost their jobs had worked for the company, which was formerly owned by Smiths Industries, for forty years. The closure severed Witney's link with Smiths Industries, which made instruments for the car industry and employed hundreds of workers.

The proximity in which Smith's employees lived and worked created a strong community spirit. A highlight of the social year was the annual Smith's Sports and Social Club sports day. In June 1962, one of the attractions was this fundraising bottle stall, where, for 2s (10p), punters could either buy a ticket for the tombola or purchase a bottle outright.

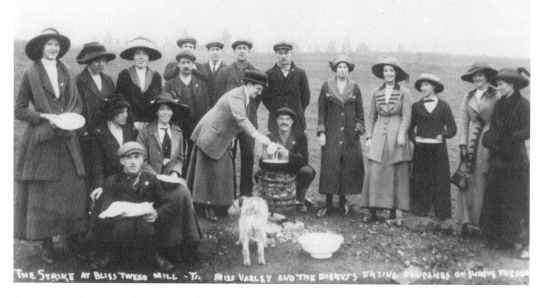

THE STRIKE AT BLISS TWEED MILL - Ti MISS VARLEY AND THE PICKETS FRYING PANCAKES ON SHROVE TUESDA

Another well-known Oxfordshire product was tweed, which was manufactured at Bliss's Chipping Norton mill. The mill dates back to the late eighteenth century, when Thomas Bliss arrived in Chipping Norton to set up a branch of his family's Gloucestershire business. By the end of the nineteenth-century production was hit by competition and the business declined until, in 1913, the formation of a trade union led to a strike. Workers were divided, some continuing to work but the strikers being left without any income during a harsh winter. The strike failed and it was not until 1945 that the union was successfully established. In this 1914 photograph, strikers and their supporters celebrate Shrove Tuesday by making pancakes outside the factory.

This gathering of Bliss's workers in September 1980 marked the closure of the last sections to function at the mill. Some of the 120 employees relocated to the company's Somerset mill and a few others found work locally, but most were out of a job. The mill site was put on the market and the listed buildings converted into accommodation.

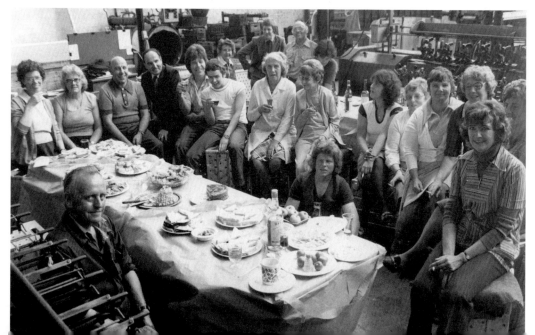

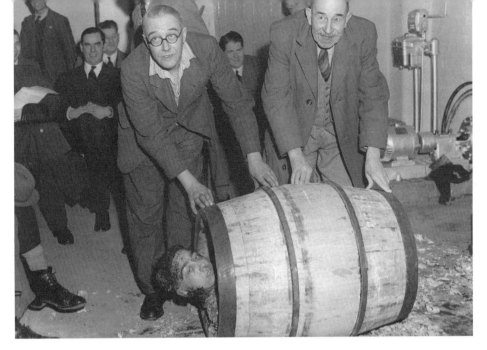

In the days before beer was stored in metal casks, coopers, or barrel-makers, were important members of brewery staff. Becoming a cooper involved a lengthy apprenticeship and its completion was a reason to celebrate. In this picture, taken at Morland's Abingdon Brewery in February 1958, Brian Cherrill is being christened as a cooper by being rolled in a barrel by his father and grandfather.

When beer had been bottled crates were needed to transport them. These lady carpenters, Mrs M. Bowell (right) and Mrs M. King, are pictured in August 1961 making wooden crates at the saw mills belonging to Watlington Brewery. The brewery itself, which was closed later in the decade, was in Couching Street, opposite Watlington Court, the former police station.

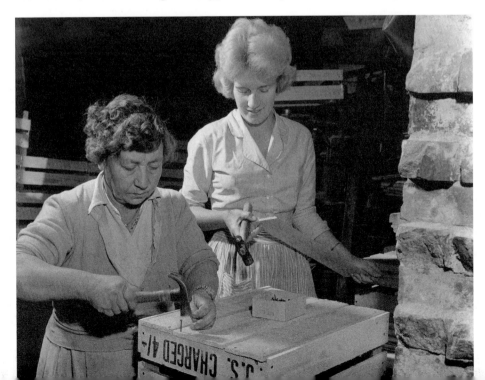

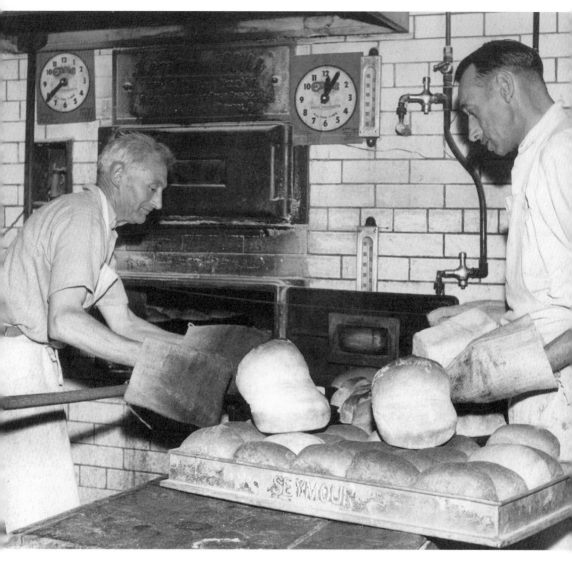

This couple of early risers taking old-fashioned lopsided cottage loaves out of the oven are Mr Percy Seymour and his assistant. In September 1961, Mr Seymour had been running the bakery in Chinnor for almost twenty years and by this date this was the only one left in the village.

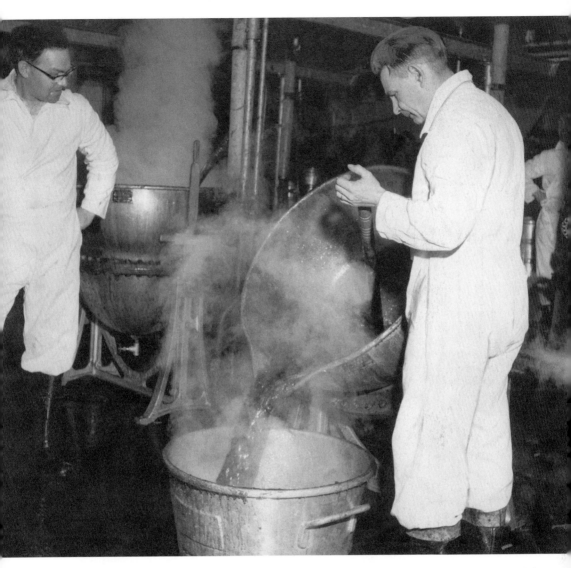

The world-famous Cooper's Oxford Marmalade was first made in a shop in the High Street in 1874, as is recorded on a blue plaque on the premises. In 1949 the business moved into the former Majestic Cinema, originally the ice rink, in Botley Road. Shortly after the company relocated to Wantage in 1964, Frank Cooper Ltd was taken over by Brown & Polson and the marmalade was produced at Paisley, near Glasgow. This photograph was taken in the Botley Road factory in March 1961.

Oliver & Gurden employees Miss Marion Adcock and Mrs P. Freeman pose with the scale model cake of Balliol College which the bakery produced for the college's 700-year-celebrations in June 1963. The company was founded in 1919 by two chefs at Keble College, William Oliver and Aubrey Gurden, in some converted stables in Summertown. After working in college, they did their baking, slept on the premises and delivered their produce by horse and cart in the early hours. In 1968 the very successful business, now in Middle Way, became part of Lyons Bakery and in 1973 changed its name to Fullers Cakes Ltd.

In the first half of the twentieth century the Cadena Café in Cornmarket was one of the leading places to meet up in central Oxford. The Cadena Bakery, which served the café and shop, was in Castle Street and during the run-up to Easter the spicy aroma of hot-cross buns could be smelt in the vicinity. In this photograph from April 1960, Miss S. Belcher and Mrs N. Bradbury load trays of buns to be sent off for sale. That year about 90,000 buns were baked.

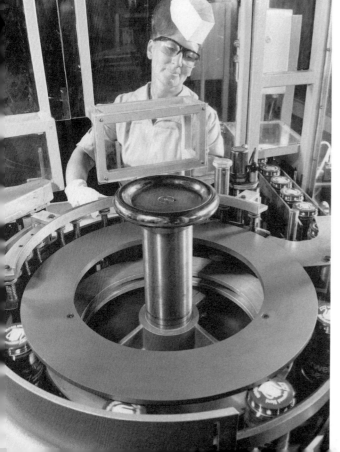

Ladies at work in the Ross Young Frozen Foods factory at Thame in January 1991. New employment opportunities were available at Thame, which had been largely dependent on agriculture, when industrial estates and business parks opened up along the Thame Park Road after the closure of the railway station in the 1960s.

A busy lady operative at General Foods Ltd, Banbury, in March 1971, in charge of a machine for filling coffee jars. The machine in this picture was able to fill 350 jars every minute and the brand of coffee was Maxwell House, which is still on the market today.

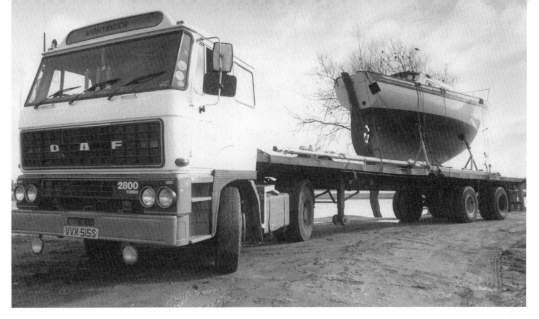

Archaeologists have shown proof of boat construction in prehistoric times at the Binsey site occupied by Bossom's boatyard. The Bossom family built boats here from around 1830 until in 1945 the last one retired. It is one of only a handful of boat-builders that took part in the first London Boat Show to remain in business. More recent history was made in 1985 when the company built its first ocean-going yacht, pictured here. It was sold to a buyer in San Francisco for £20,000 and was shipped across the Atlantic in a cargo vessel.

In September 1956, when the future of the car manufacturing industry was in question due to a credit squeeze, the two-millionth Nuffield vehicle built since 1912 rolled off the assembly line. This was a Morris Minor and it was presented as a gift to the National Institute for the Blind – presumably to raffle or auction off – by William Morris, Viscount Nuffield.

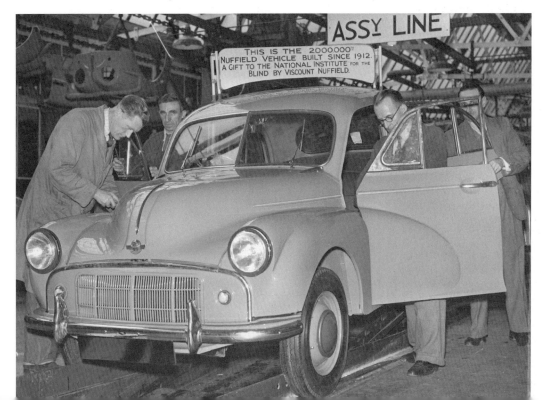

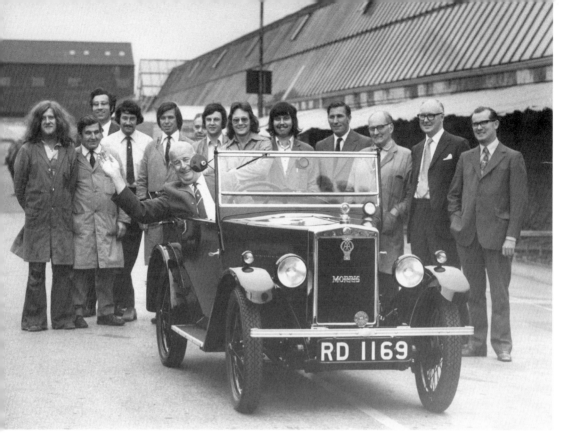

When George Smith retired from the Cowley car assembly plant in September 1974, he left the factory in a car which he had helped to make more than forty years previously. This was a 1932 Morris open tourer, one of the oldest cars kept in the works, which had been polished up to play its part in Mr Smith's farewell gathering.

Opposite above: In March 1957, when the 7,000 Morris motors workers received their weekly wages in cash, pay day was on a Friday. This cash dispenser is a Brandt Paying Machine and when keys were hit, coins poured out into the wage packets.

Opposite below: While the coins were dispensed by machine, the paper money (which in 1957 were £1 and 10s notes) were counted and put into the workers' pay packets by hand. Seventy pay clerks each handed over more than a hundred pay packets in five minutes every week after dozens of clerks had spent five days working out the correct amount to go into each.

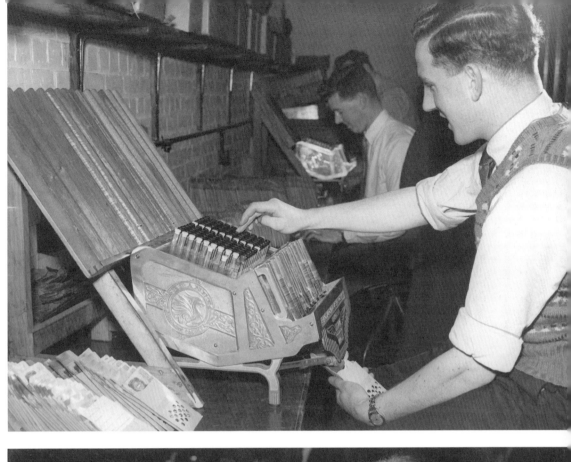

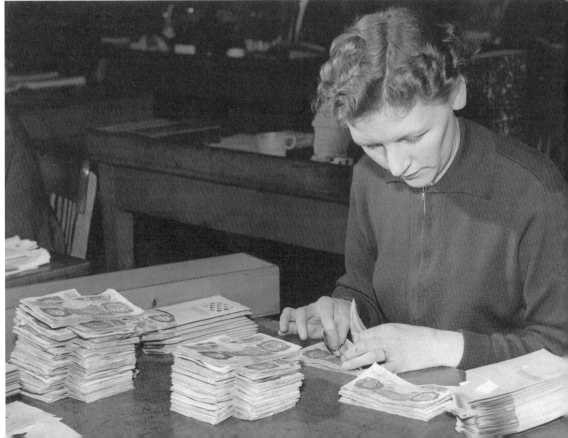

Oxfordshire's other car factory was the MG (Morris Garages) works at Abingdon. In July 1976 these six members of a syndicate hit the jackpot with a Pools win of over £83,000. The syndicate, which had been running for over two years, were told by Littlewoods to expect a payout of at least £30,000 but in the event they received nearly £13,900 each. From left to right are Peter and John Brakespear, Kevin Goodenough, Gordon Webb, Maurice Coles and John Stunell.

The world-beating Williams Grand Prix team posed for this celebration photograph in September 1982. This was the second world championship win for the Didcot factory in three years. The champion driver, Keke Rosberg, who took the title in Las Vegas, was supported by the fifty or so back-up staff in Oxfordshire.

In 1745, the same year that Scottish clansmen rose up in support of Bonnie Prince Charlie, Leonard Knapp of Clanfield set up in business making and repairing agricultural implements. It became L.R. Knapp & Co. Ltd and when foreman Ben Neville was photographed with a century-old horse drill in October 1962, it could claim to be the longest-established manufacturer of implements in the United Kingdom.

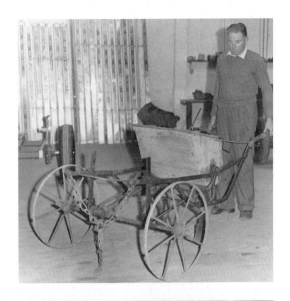

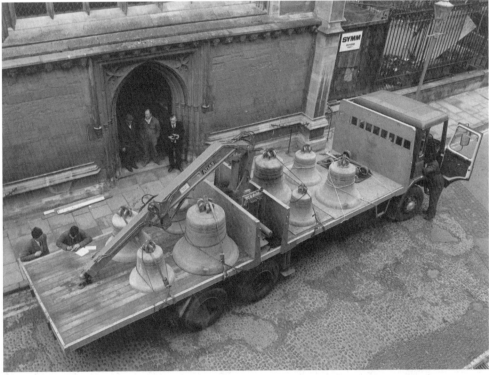

These eight bells belonging to Merton College Chapel are off to London to be retuned. The bells, which were cast in 1660 and had last been retuned in 1880, were lowered by bell-hanger Brian White of Yarnton, whose great-grandfather Frederick had done the same job in 1880. White's of Appleton was founded in 1824 by Alfred White, licensee of the Greyhound at Besselsleigh, where he also ran a bakery, the village shop and a forge. There he carried out his first work on bells and many oak bell-frames were constructed in the yard at the rear of the inn. Alfred started trading as A. White, Bellhanger, and, after taking his sons into the business, traded as A. White & Sons.

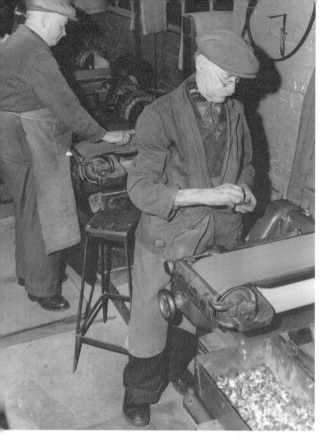

W. Lucy & Co. Ltd, Oxford, had already been in business at the Eagle ironworks in Oxford's Jericho for over a century and a quarter when they were featured by the *Oxford Mail* in 1957 for offering employment to older men for less exacting job which were shunned by ambitious younger men. The workers here are seen tending machinery.

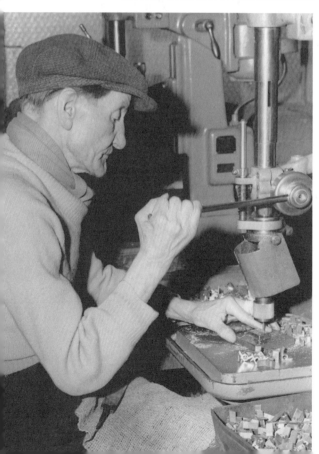

Most of these older workers, several of them in their seventies, had already retired from other jobs and others were disabled in some way. This partially disabled man, who has no difficulty in operating a power drill, was still able to make a contribution to the local economy thanks to Lucy's employment policy. Although the Jericho works have closed, Lucy's head office remains in Walton Well Road and the company still makes iron castings at the Sandawana foundry in Witney.

The village of Chinnor is situated in the chalky Chiltern Hills. A lime-manufacturing business was started in 1908 using five beehive kilns. This lone survivor, shown in September 1961, is now listed; it was in use from 1909 to 1970. In 1936, the works expanded into cement production on being acquired by the company Rugby Portland Cement. The large site, with its distinctive chimney, railway and chalk quarry, contributed to Chinnor being branded 'the ugliest village in the Chilterns.' For the next few decades it became an important employer in this part of Oxfordshire, with workers coming to Chinnor from surrounding towns and villages. In 1990, when production was at its maximum, some 5,600 tons of cement were exported every week.

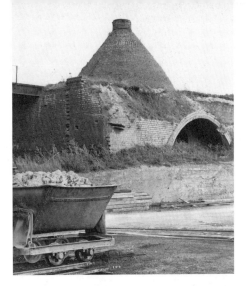

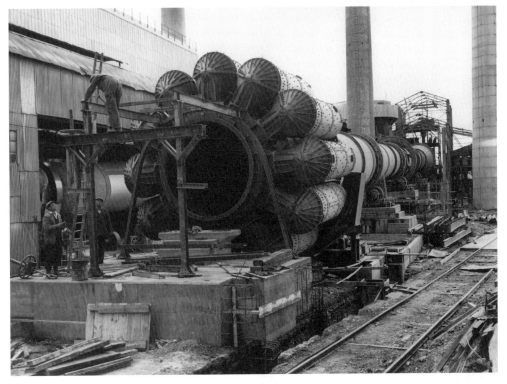

This view of the cement works was taken from the firing end of the new Vickers kiln during the course of its construction in May 1959. The works closed in 1999, and visitors were able to gain access to the unsupervised site, which was dangerous, not only because of physical hazards but also because of the amount of chalk dust in the air. The site has featured in an episode of *The Bill* and as a setting for the James Bond film *Die Another Day*. In the summer of 2009, Thames Valley Police, the Emergency Services and the *Oxford Mail* expressed concern about the fact that 'the development site pits have been an attraction for young people for many years.' They stated that the site was very dangerous, with contaminated water due to recent demolition work. New safety measures were put in place, with twenty-four-hour security.

Other titles published by The History Press

Oxford in the 1950s & '60s
MARILYN YURDAN

Oxford in the 1950s & '60s offers a rare glimpse of life in the city during this fascinating period. As this amazing collection of 200 photographs shows, there is much more to these two decades than pop groups and mini skirts. Including views of Oxford's streets and buildings, shops and businesses, pubs and hotels, the Colleges and University departments, as well as some of the villages which form the suburbs of the city, this book is sure to appeal to all who remember these decades and everyone who knows and loves Oxford.

978 0 7524 5219 7

Oxfordshire Graves and Gravestones
MARILYN YURDAN

Local author Marilyn Yurdan takes the reader on a tour of the county's graveyards, including the largest Anglo-Saxon cemetery in England and a Medieval Jewish cemetery under Oxford Botanic Garden, and reveals the poignant, humorous, and sometimes gruesome history behind Oxfordshire's graves and gravestones. Among the gravestones featured here are those commemorating politicians, academics, soldiers, artists, poets and writers, as well as some more unusual people, including the first English balloonist, the soldier who fired the first shot at Waterloo, and a Maori lady.

978 0 7524 5257 9

The Street Names of Oxford
MARILYN YURDAN

This book traces the origins of names found in Oxford, not only of its streets, villages, suburbs and housing estates, but also of the various colleges which make up the university, many of which have had a considerable influence on its streets. Containing illustrations that range in date from nineteenth-century prints to photographs of modern developments, this book is a must-read for everyone interested in Oxford's development.

978 0 7509 5098 5

Banbury In Old Photographs
MARILYN YURDAN

This superb selection of 200 photographs provides a nostalgic insight into the changing history of the town over the last century. Each image is accompanied by a detailed caption, bringing the past to life and describing many aspects of life in the town, including chapters on work, industry, schools, markets, fairs and local events – including the annual Banbury Hobby Horse Festival – and providing a vital record of vanished vistas and past practices.

978 0 7524 5606 5

Visit our website and discover thousands of other History Press books.
www.thehistorypress.co.uk